IMAGES
of America

BASEBALL IN
ORANGE COUNTY

On the Cover: This is a c. 1909 photograph of the Anaheim Oil Wells baseball team. (Courtesy of Anaheim Heritage Center.)

Chris Epting

ARCADIA
PUBLISHING

Copyright © 2012 by Chris Epting
ISBN 978-0-7385-9328-9

Published by Arcadia Publishing
Charleston, South Carolina

Printed in the United States of America

Library of Congress Control Number: 2011943765

For all general information, please contact Arcadia Publishing:
Telephone 843-853-2070
Fax 843-853-0044
E-mail sales@arcadiapublishing.com
For customer service and orders:
Toll-Free 1-888-313-2665

Visit us on the Internet at www.arcadiapublishing.com

To Brian Nicalek, who is as passionate and knowledgeable as any Orange County baseball fan that ever entered a ballpark

Contents

Acknowledgements		6
Introduction		7
1.	Walter Johnson, the "Big Train"	9
2.	The Seeds of Orange County Baseball	19
3.	"A Monster Athletic Contest"	33
4.	Lionettes, Valencias, Los Juveniles, and Some Big Stars	45
5.	The California Angels Arrive	71
6.	Local Legends	87
7.	Museums, Markers, and Memorials	97

ACKNOWLEDGMENTS

History books like this are truly labors of love and would not be possible without the generosity, time, and consideration of many people and resources. I would like to acknowledge and thank Jane K. Newell, heritage services manager at the Anaheim Public Library; Richard Santillan, whose wonderful research on Mexican baseball heritage in Southern California has already produced two fine Arcadia books (with more to come); Cheri Pape, curator at the Local History Room at the Fullerton Public Library; Lizeth Ramirez, local history librarian at the Orange Public Library; Irma Morales Sr., library manager at the Orange Public Library; Chris Jepsen at the Orange County Archives; Terry Canon from the Baseball Reliquary; Hank Thomas and Chuck Carey for their tremendous research on Walter Johnson; Wendy Kotkosky for her Huntington Beach Little League photographs (her son Steven's home run in the sixth inning of Western Regionals put the team in the Little League World Series); the Newport Sports Museum; and Tom Meigs, Tom Duino, Richard Wojcik, and John Outland for their wonderful photographs.

Gratitude also goes to Amy Perryman and her fine team at Arcadia Publishing and Jerry Roberts for suggesting this book idea in the first place.

And, of course, to my wife, Jean, daughter Claire and son Charles—thanks for always being the best "home team" in the world.

Some images in this volume appear courtesy of the Anaheim Public Library, Fullerton Public Library, Orange Public Library, and Orange County Archives. Unless otherwise noted, all other images are property of the author.

INTRODUCTION

For many Orange County baseball fans, the arrival of the California Angels in 1966 all but heralded the beginning of real baseball history in the area—and that is understandable. After all, since arriving in 1958 in nearby Los Angeles after relocating from Brooklyn, the Dodgers had commanded immense attention, and for many the Angels put Orange County baseball on the map.

But just like the rich pre–Dodger baseball era in the Los Angeles area, Orange County also boasted an impressive amount of history. It may not have been at the major-league level, which justifiably generates a high amount of attention and enthusiasm, but it was still extremely important to many locals and actually helped set the stage for the arrival of the Angels.

Going all the way back to the late 1800s, baseball played a very important part in the development of Orange County. Everyone knows the Angels, but many are unaware that Walter Johnson, one of the greatest pitchers in baseball history, learned to play baseball in Orange County, or that he returned in 1924 to play a now-legendary game against a team led by Babe Ruth.

Many do not know how organized the oil well teams were in the early 1900s and how oil companies actually recruited strong, young players so they could have the most dominant teams.

And there is much more to the story of Orange County baseball history. Jackie Robinson came to Anaheim to film the story of his life at a little ballpark called La Palma, which is also the place where Joe DiMaggio played while stationed in the Army. It is also the spot where the Anaheim Valencias won the Sunset League championship in 1947, as well as where manager Connie Mack brought his Philadelphia Athletics for spring training in the early 1940s.

There was the Southern California Trolley League, which was only in existence in 1910, featuring teams that were connected by trolleys running between their cities. Orange County's league entry was the Santa Ana Yellow Sox, which was joined by the Redondo Beach Wharf Rats, Long Beach Sand Crabs, Los Angeles McCormicks, Pasadena Silk Sox, and Los Angeles Maiers.

There were the Mexican players who, shamefully, were not allowed to play with white teams due to segregation, so they formed teams, like Los Juveniles, that played in their own leagues.

There was the legendary female team the Orange Lionettes and famed ballparks like the aforementioned La Palma Park, Amerige Park in Fullerton, and Hawley Park in Santa Ana.

What about the day Yankee legends Babe Ruth and Lou Gehrig came to Orange County to hunt? Speaking of Babe Ruth, did you know his last-ever home run ball is located in an Orange County museum that features one of the world's greatest collections of baseball artifacts?

There are many other players, stories, anecdotes, bits of trivia, and revelations about Orange County baseball. They are all part of the story and are here, along with many extremely rare photographs, representing the full story of the history of baseball in Orange County.

Then, of course, there are the Angels, who played their first game in Orange County in 1966. While it would have been easy (and interesting) to primarily focus on the Angels given their own 50-year history, that is not what this book sets out to do. There are several fine books that

document Angels history, and given the space I had to work with, I chose to focus my emphasis on their arrival in Orange County, the construction of their ballpark (Angel Stadium), and several other key franchise events.

Also, while it would have been nice to feature every ballplayer from the area, along with every player laid to rest in Orange County, due to space limitations I chose the players who seemed to best represent the sport.

I chose to organize the book into seven chapters. It begins with the arrival of a teenaged Walter Johnson in the early 1900s and traces his footsteps throughout Orange County. Next, it is on to the first full era of Orange County baseball (1880 to 1930), when many high school teams and organized leagues had begun, along with a host of semiprofessional teams. It then goes on to a chapter dedicated to a near-mythical game that took place in Brea on October 31, 1924, when Walter Johnson returned home to play against a team fronted by Babe Ruth. What makes this chapter truly unique are the rare photographs taken that memorable day by George Outland, which are presented here for the first time. Chapter four captures the mid-century baseball history, a time when stars such as Jackie Robinson and Joe DiMaggio played here and Orange County became a popular spring-training destination. After that, it is time to look at the arrival of the California Angels and some of the more well-known players who hail from Orange County. Finally, readers will enjoy a mixed bag of sorts, a chapter that includes baseball plaques, markers, memorials, museums, and final resting places that all have an Orange County baseball connection.

I hope you find there is more than enough here to make the case that the baseball history in Orange County is compelling and significant. Starting with Walter Johnson and ending with a breathtaking 2011 Little League World Series Championship, the county once defined by citrus groves and oil fields has been a hotbed of baseball activity since the time it was founded in 1889 (there was actually already organized baseball in Orange County that year, as you will learn).

The county has produced several Hall of Famers and dozens of others well-known players, it has hosted three Major League Baseball All-Star Games and even featured a World Series Championship in 2002 when the Angels beat the San Francisco Giants in a memorable seven-game battle.

But the real stories lie out in the oil fields, dust, and dirt where the lesser-known games took place; where one can still stand and say, "This is where Walter Johnson first played baseball." Even though some of the ball fields have been replaced with homes, parking lots, or shopping malls today, it does not matter. The stories still live in the air and are told here. And, thankfully, several places like La Palma Park and Amerige Park still exist, so new history is being made every day.

As most fans are aware, baseball's national anthem, "Take Me Out to the Ball Game," is played during the seventh-inning stretch at most major-league games (and many minor-league games as well). To me, one of the most stunning things about Orange County baseball history is that the song's lyricist, Jack Norworth, a longtime Orange County resident, was laid to rest within view of Angel Stadium in Anaheim. He lived in Laguna Beach for decades, and to this day a trophy presented to him in 1958 is still the cherished prize that goes to the winning Little League team each year in his adopted beach community. He helped establish the first Little League team in Laguna Beach while living in a small Pacific Coast Highway apartment with his wife, where they ran a small curio shop.

The reader will learn more about Norworth in this book, along with a lasting memorial that was recently created for him. And it is exactly the sort of story that brings the bigger picture of Orange County's profound effect on the game, as well as the game's profound effect on Orange County, to life.

One

WALTER JOHNSON, THE "BIG TRAIN"

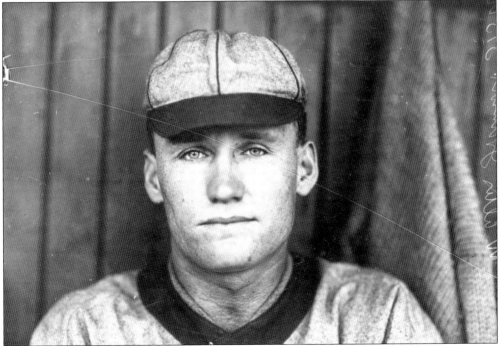

When Ty Cobb of the Detroit Tigers first played against Walter Johnson, who started his legendary baseball career in Orange County, he recalled, "The first time I faced him, I watched him take that easy windup—and then something went past me that made me flinch. I hardly saw the pitch, but I heard it. . . . Every one of us knew we'd met the most powerful arm ever turned loose in a ballpark."

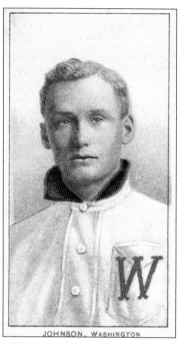

Walter Perry Johnson was born on November 6, 1887, in Humboldt, Kansas. He lived on a farm there until 1901, when his father, Frank, transplanted the family to the oil fields of Olinda, California. Walter became a baseball player in Olinda, learning the game on makeshift diamonds near the oil fields. He played for several local teams, including the Olinda Oil Wells and Fullerton Union High School. On April 15, 1905, he pitched in a 15-inning, 0-0 game for Fullerton against Santa Ana High School and struck out 27—the legend was born. This image shows Johnson on an American Tobacco Company advertising card, part of the famed 1909 T206 White Border Set.

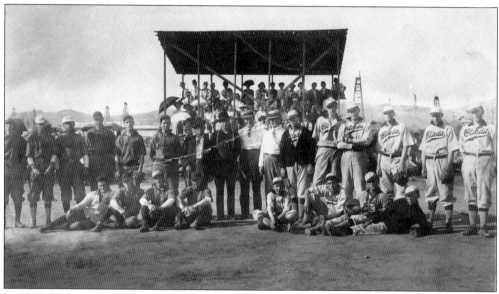

In 1902, Walter was enrolled in Olinda School, where Carbon Canyon Regional Park is today. This is also the year he started playing baseball. As Henry Thomas, Walter Johnson's grandson, wrote in his wonderful book, *Walter Johnson: Baseball's Big Train*, "There was no real ballpark in Olinda, just a rough diamond laid out on 'the flat' below a livery stable on Santa Fe Avenue. As the Oil Wells team improved, and took on better competition, fan interest grew and a more suitable place to play was needed." This is a photograph of the Olinda Oil Wells team from around the time Johnson played here. It has been suggested by some that he is in the image, but the author has been unable to prove this conclusively. The grandstand here existed near Valencia Avenue and East Lambert Road, behind where Martin's Drugstore used to exist. Today, the lot is still an open area.

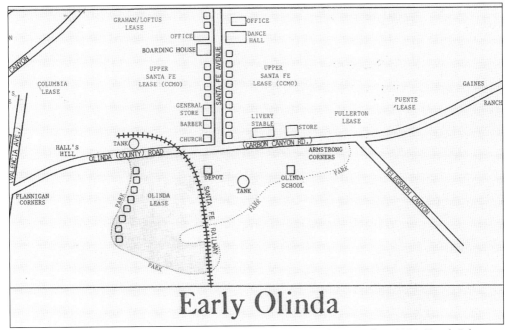

This is a map of how Olinda looked when the Johnson family arrived in 1901. Frank Johnson, Walter's father, worked on the Santa Fe oil lease, which can be seen left of center. To the right of Santa Fe Avenue, near the livery stable, is where Walter first practiced throwing a baseball. Today, the area has been residentially developed.

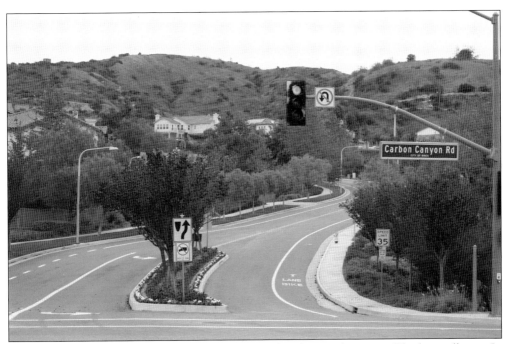

Today, Santa Fe Avenue remains, but the collective oil settlements known as Olinda are all gone. In 1911, Olinda Village and the nearby town of Randolph were incorporated as the city of Brea.

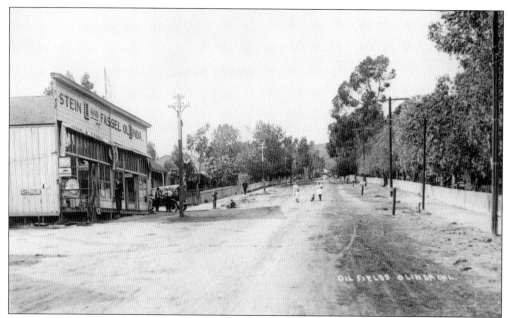

This is Santa Fe Avenue as it looked not long after the Johnsons moved to Olinda from Kansas. Henry Thomas, Walter Johnson's grandson, recalls, "Even before the Johnsons' arrival, the Olinda 'Oil Wells,' as they were known, were taking on nines from the nearby towns of Santa Ana, Rivera, Downey, Ventura, and Pomona, and a handful of fast semipro outfits from Los Angeles. The names of the L.A. teams often reflected the companies that sponsored them: Hamburgers was a department store; Hoegees, a sporting goods concern whose uniforms 'have been found stout enough to slide to base on.'"

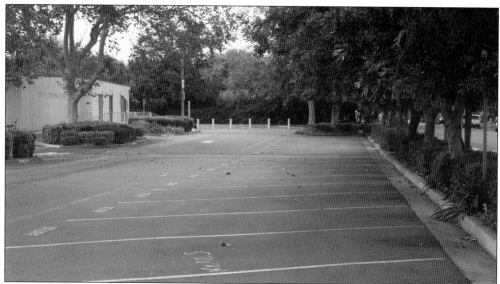

Louis Plummer wrote in his fine book *The History of Fullerton Union High School and Junior College*, "After a brief stay at the corner of Wilshire and Harvard avenues the school was housed in a brick building on the corner of Wilshire and Lawrence. Here it stayed until the summer of 1908 when a new home was ready for it on West Commonwealth." This is the site of Fullerton High School, where Johnson was a student; today, it is a parking lot.

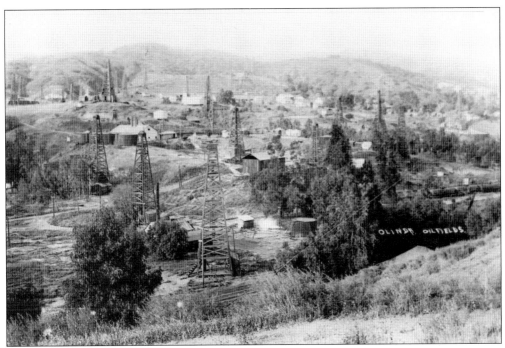

This image shows the oil fields of Olinda as they looked to a young Walter Johnson. Henry Thomas wrote, "Meanwhile, Johnson continued striking out the boys on the flat, and soon there was talk about it in the stores and around the oil derricks, where baseball was always the main topic of conversation. Joe Burke, a bookkeeper with the Santa Fe railroad (and later the Los Angeles District Attorney), had been a player and manager with earlier incarnations of the Olinda Oil Wells team. He still suited up on occasion, and his continuing interest in the team led to his being the original 'discoverer' of Walter Johnson."

According to Henry Thomas, "The first game of baseball Walter Johnson ever witnessed, in fact, was one of these contests at Anaheim. He was fourteen years old, and it would be two years yet before he would play in a game himself. . . . For several years after his arrival in Olinda, Walter's involvement in baseball was limited to being a spectator at the games in Anaheim—that, and the typical boy's fascination with the great stars of the major leagues." This is the site in Anaheim where Johnson first watched organized baseball, on South Atchison Street just off East Broadway.

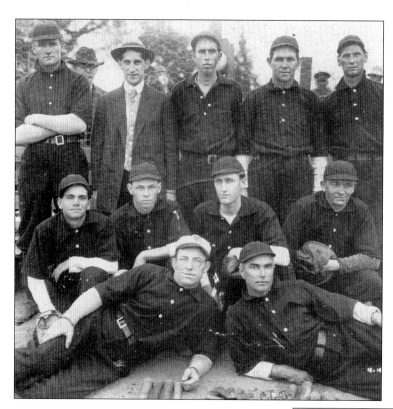

Walter Johnson is seen here (back row, far left) as a member of the 1909 Santa Ana Yellow Sox. Taking advantage of the publicity surrounding Johnson's new major-league career, the Yellow Sox declared December 26 "Johnson Day" at Hawley Park. Two thousand portraits of Johnson were made, and he delivered them to the fans himself.

This is one of the photographs given out by Johnson in Santa Ana on December 26, 1909, in honor of his day at Hawley Park. The California Winter League was well under way by 1909 when Johnson joined up with Santa Ana for the third time, which was to be his final season of baseball on the coast.

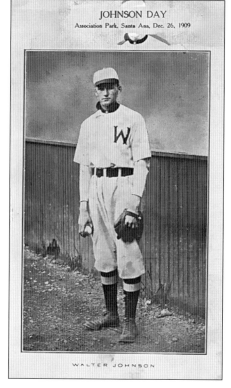

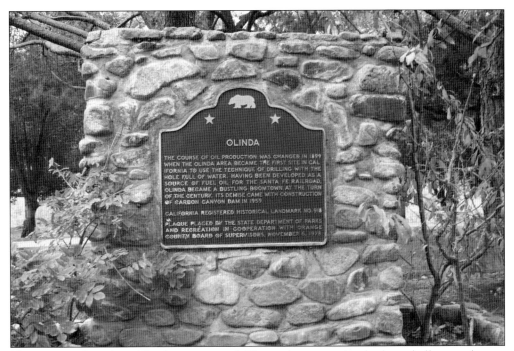

There is a marker where Olinda once existed. The settlements, schools, dance hall, general store, church, and livery stable are all gone without a trace.

In the shady, quiet groves of beautiful Carbon Canyon Regional Park, one is forced to simply imagine what it was like back then.

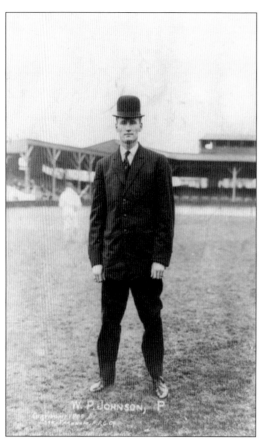

Fred Snodgrass recalled in the wonderful Lawrence Ritter book *The Glory of Their Times*, "At the time, the only contact I had with baseball was playing Sundays on a semipro team called the Hoegee Flags. We played teams all over southern California, and I still remember the one that was the toughest. It was a team down by Santa Ana, for which Walter Johnson pitched. If people think Walter was fast later on, they should have seen him then. Whew! Most of the time you couldn't even see the ball!" This photograph shows Johnson the year after he left Olinda for good in 1910, on his way to becoming a legend.

Today, the pulse of old Olinda beats on the hills, where many of the oil wells still pump away. These are the hills where Walter Johnson would have worked and played as a child.

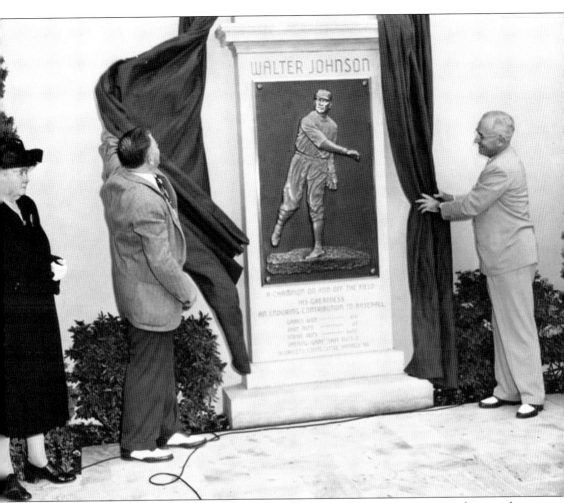

Walter Johnson later moved to Idaho, where he doubled as a telephone company employee and a pitcher for a Weiser-based team in the Idaho State League. Johnson was spotted by a talent scout and signed a contract with the Washington Senators in July 1907 at the age of 19. He would not return to pitch in Orange County until 1909, when he made his last appearance in the California Winter League. He did not pitch in Orange County again until October 31, 1924. This image shows a plaque dedicated to Johnson at Griffith Stadium in June 1947 during a ceremony presided over by Pres. Harry Truman and Senators owner Clark Griffith (Johnson had died the year before). Today, the plaque can be found at Walter Johnson High School in Bethesda, Maryland.

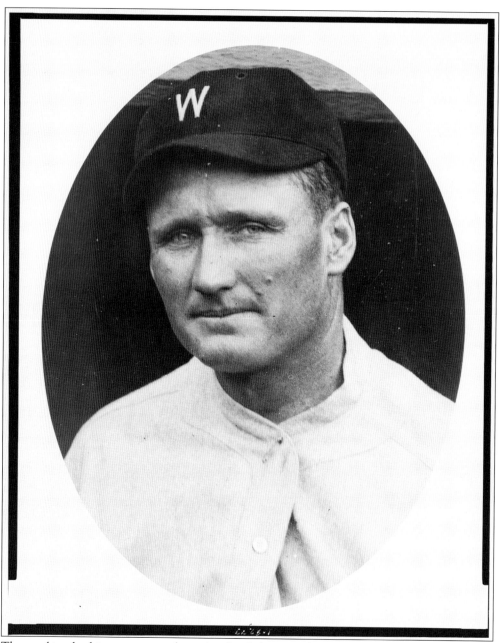

The combined achievements are almost hard to fathom. Walter Johnson struck out 3,508 batters (the most until Nolan Ryan broke his record in 1983). He also led the American League in strikeouts 12 times, shutouts seven times, and was league leader in wins six different times. For his career, he ranks third overall in innings pitched with 5,923, fifth all-time in complete games with 531, and no one in history has more shutouts than his 110. His lifetime winning percentage was .599, and he is the only pitcher in major-league history to win 20 games and hit .400 in a season. Johnson also won 417 games. Along with Christy Mathewson, Babe Ruth, Ty Cobb, and Honus Wagner, Johnson was honored as a member of the first class inducted into the National Baseball Hall of Fame.

Two

THE SEEDS OF ORANGE COUNTY BASEBALL

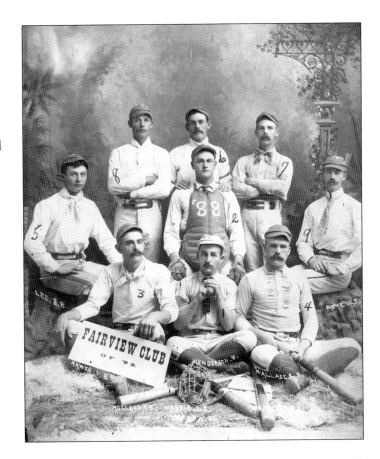

This is the oldest photograph in the book, if not the earliest baseball photograph in Orange County. Dating back to 1888, the caption reads, "Fairview Club of '88 baseball team group portrait, Fairview Park, California, 1888." Fairview, a railroad boomtown, sprang up around what is today the intersection of Harbor Boulevard and Adams Avenue (now Costa Mesa) in 1887. The town died off over the span of a few years. By 1908, it was merely a ghost town, and today not a trace of it remains. (Courtesy of Orange Public Library.)

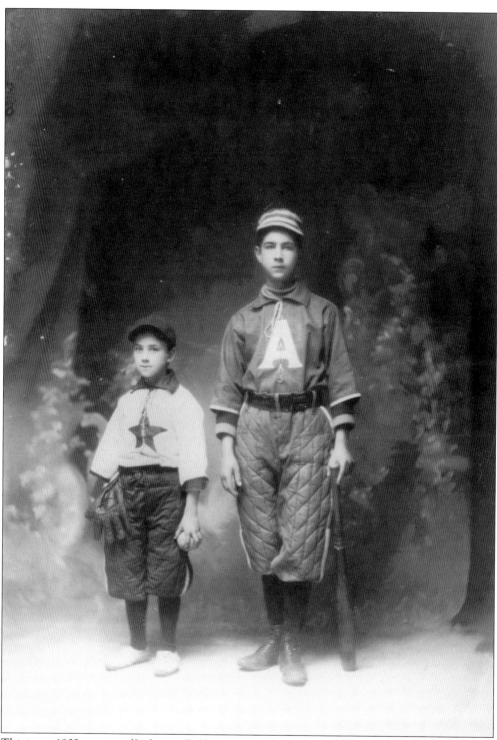

This is a c. 1903 portrait of Lafayette (left) and Leland Lewis dressed for a baseball game. They were the sons of Louis and Arthur L. Lewis, the first superintendent of the Anaheim Municipal Light and Water Works, who held the post from 1907 to 1916. (Courtesy of Anaheim Public Library.)

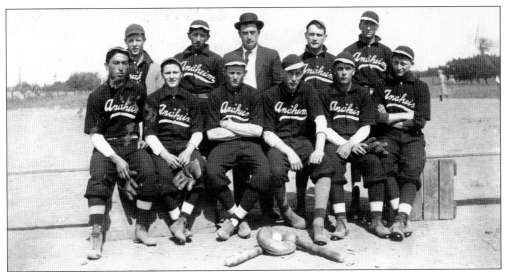

Around 1904, the City of Anaheim built a baseball park called Athletic Park on Atchison Street near the Santa Fe Railroad station. The year before, the *Los Angeles Times* reported, "A lease was signed which will give Anaheim the finest baseball park in Orange County." It could hold more than 1,000 fans, and so it became a popular place for many teams to play, drawing people from Santa Ana, Olinda, and Placentia, among other places. Information about the park is scant, and photographs are all but nonexistent, but it is believed that this Anaheim team is posed at the park around 1905. (Courtesy of Anaheim Public Library.)

This image was captured at the present-day site of Athletic Park in Anaheim where the infield would have been. On Sunday, July 20, 1905, the Olinda team played two games, one during the day and one at night, versus a team of Sioux Indians from South Dakota. As an ad promised, "50 arc lamps will illuminate the grounds for the evening game. The Indians have been secured for these two games under a heavy guarantee. They travel in their own private cars, use their canvas fence for enclosure and erect their own portable grandstand, which is protected by a mammoth canvas covering and netting to protect spectators from foul balls." About 1,000 fans attended, paying 25¢ per ticket to see the Olinda ball team defeat the Indian nine at Anaheim by a score of 10 to 6.

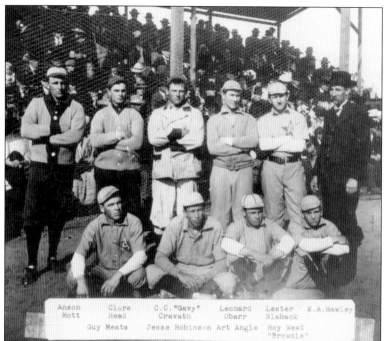

This is the 1908 Hawley baseball team pictured at Hawley Park in Santa Ana. The names noted on the bottom of the photograph are Anson Mott, Clare Head, Guy Meats, C.C. "Gavey" Cravath, Jesse Robinson, Leonard Obarr, Art Angle, Lester Slaback, Roy West "Brownie," and E.A. Hawley, whose sporting-good business sponsored the team and built the ballpark.

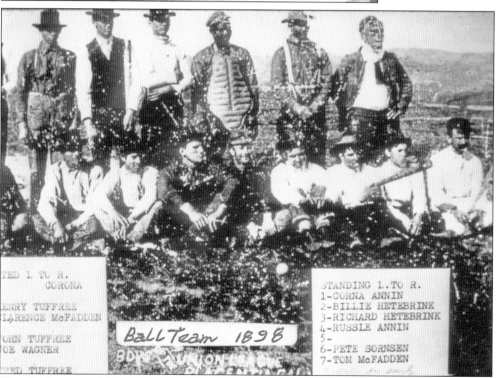

This 1898 image of the "Boys of the Union League" features offspring from several prominent Placentia ranch families. Perhaps most interestingly, the team also includes an African American, a bold statement at a time when racial segregation and Jim Crow laws were all but a way of life across the country.

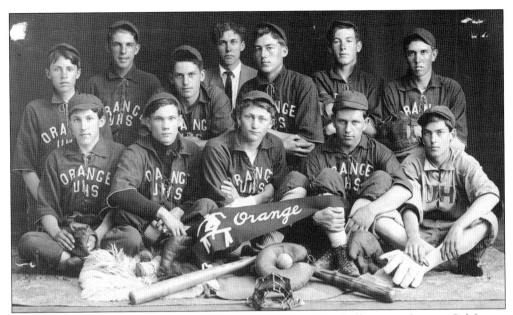

In this c. 1910 image is the Orange Union High School boys' baseball team in Orange, California. The players display an "Orange" pennant with two crossed bats resting behind a catcher's mitt and mask. Joe Hinrichs is seated behind the pennant, and Fred Kelly is behind him, third from the left. (Courtesy of Orange Public Library.)

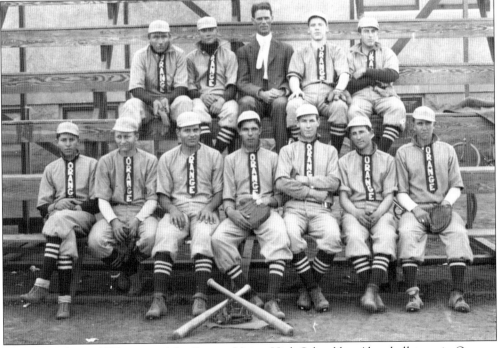

This is another c. 1910 image of the Orange Union High School boys' baseball team in Orange, California. The original caption reads, "Postcard shows group portrait of 11 boys in uniform with their coach sitting in two rows of bleachers with two crossed bats resting on a catcher's mask at their feet." (Courtesy of Orange Public Library.)

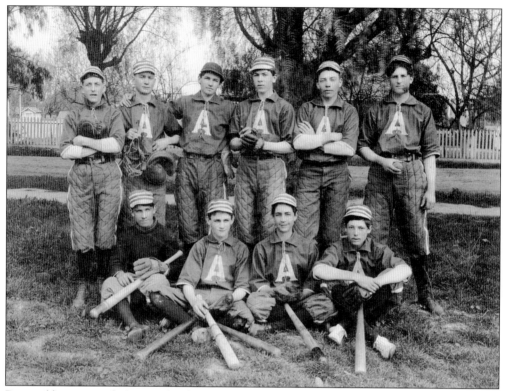

Pictured here around 1910 is school-age Anaheim baseball team. They are identified from left to right as (sitting) Ned Merritt, Chris Fischer, Fay Lewis, and Dwight Stone; (standing) E. Hartung, Bill Fischer, Ted Dickel, Elmer Stone, H. Westerman, and Fred Conrad. They are posing in a neighborhood as opposed to near a ball field or in a studio, as many of these team portraits were captured. Note the elaborate stitched pants and lace-up jerseys. (Courtesy of Orange Public Library.)

This c. 1910 image shows a group portrait of the YMCA baseball team of Orange, California. The players are, from left to right, (first row) third baseman Ted Witt, pitcher Elmer Morrison, coach Clyde Newton, shortstop Bill Downey, and second baseman Henry Meehan; (second row) outfielder Les Slabach, outfielder Bert Reeves, first baseman Jack Pratt, catcher Guy Meats, and outfielder Jack Roberts. (Courtesy of Orange Public Library.)

Many businesses got involved with baseball teams, and this is the Orange Merchant's Baseball Team in Orange, California, around 1910. From left to right are (seated) William Hagen, Kellar E. Watson Sr., John Morrison, Bert Klunk, John McCarty, and Frank Hallman; (second row) Walter Pixley, E.H. Smith, Ernest W. Bolinger, Walter Kogler, and Ed Peere. (Courtesy of Orange Public Library.)

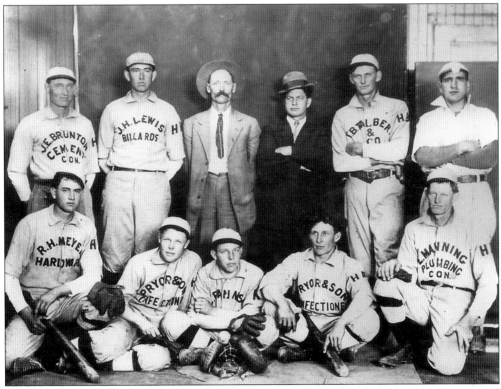

Like many cities and towns, Huntington Beach's amateur-league baseball teams were sponsored by local merchants. In this c. 1910 image, Huntington Beach's first mayor, plumber Ed Manning, who was also a team sponsor, is in the back row, fourth from the left. After oil was discovered in the early 1920s, Standard Oil built its own fairly substantial company ballpark-grandstand at what is now the corner of Twenty-third and Golden West Streets that was also used by other local amateur teams. Unfortunately, there are no known photographs of the park.

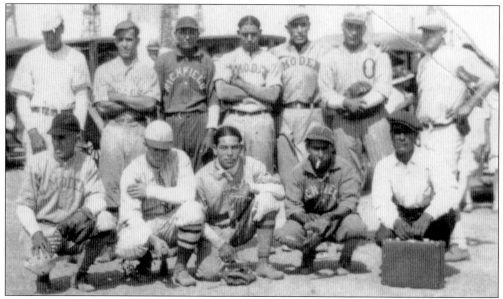

This photograph shows the El Modena and Atlantic Richfield baseball teams in 1915. The image caption reads, "Group portrait of members of the two teams in baseball game, El Modena baseball team vs. Atlantic Richfield baseball team, 1915. Viviano Bracamontes is at the far left on the back row. Behind the group are oil derricks." El Modena is located in the city of Orange. (Courtesy of Orange Public Library.)

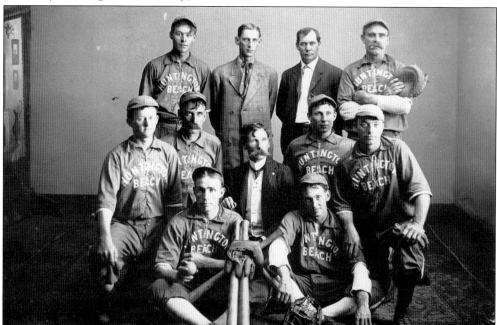

Huntington Beach, along with Anaheim, Santa Ana, Placentia, Orange, Olinda, and Fullerton, was another early hotbed of Orange County baseball. After oil was discovered in Huntington Beach in the early 1920s, company teams began to form, but even before that organized teams were playing in the coastal town. A Mexican league team formed in the 1940s. (Courtesy of Orange County Archives.)

This is a c. 1919 image from an Orange Union High School baseball game in Orange, California. The field was east of the campus along Palm Avenue. (Courtesy of Orange Public Library.)

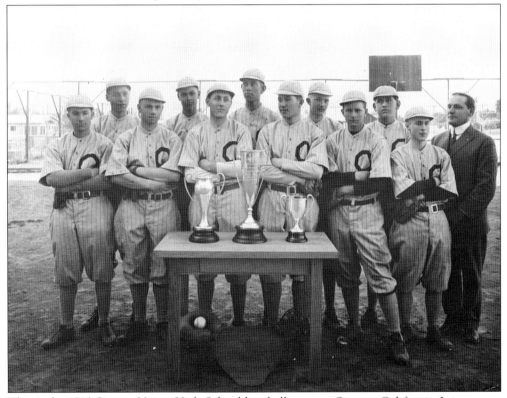

This is the 1916 Orange Union High School baseball team in Orange, California. It is a group portrait of 11 players dressed in uniforms, along with their coach, posing in front of three trophies resting on a table. A catcher's mitt and ball, face mask, and chest protector are on the ground beneath the table. (Courtesy of Orange Public Library.)

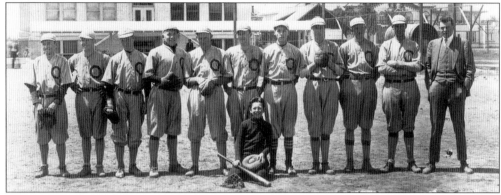

This Orange Union High School baseball team portrait is from 1916. The team members standing on the field at the high school are, from left to right, "Monk" Everett, "Bub" Mitchell, "Gowdy" Potter, Cecil Farrar, Bill Eckles, Mike Eltiste, Harry Nufer, Earl Clabby, Virgil Pritchard, "Cash" Gearhart, "Sleepy" Gelderman, and coach Barnard. (Courtesy of Orange Public Library.)

This is a studio portrait of the Santa Ana All-star baseball team in 1906; Henry J. Hinrichs is in the back row, second from the right. Henry was born in 1899 at the family home on Eckhoff Street in Orange, California, where his family owned an orange grove. (Courtesy of Orange Public Library.)

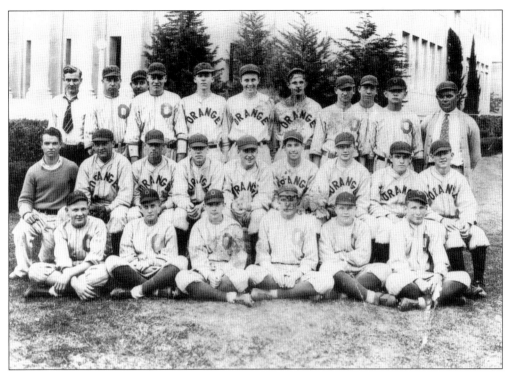

Here is the Orange Union High School 1929 baseball team posing on the school campus in Orange, California. (Courtesy of Orange Public Library.)

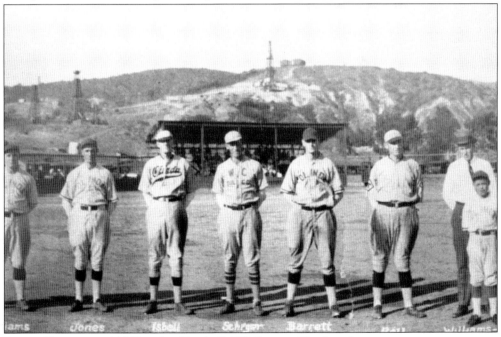

Pictured here around 1908 is the Olinda Oil Well team. The fact that many young, strong men were needed to work in the oil fields usually ensured that oil-company teams such as Olinda were fairly competitive.

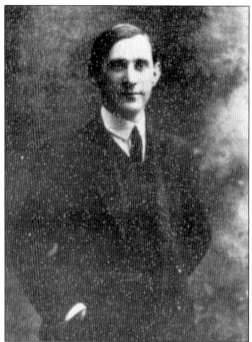

In 1910, the Santa Ana Yellow Sox, part of the ill-fated Southern California Trolley League (along with the Redondo Beach Wharf Rats, Long Beach Sand Crabs, Los Angeles McCormicks, Pasadena Silk Sox, and Los Angeles Maiers) played at Hawley Park. All the teams were located in the Greater Los Angeles area, which meant that teams could go from game to game by streetcar, hence the league's name. Managed by Ed Crolic, the Yellow Sox (and the league) lasted just one year.

Hawley Park was located in Santa Ana on the north side of Ninth Street, just west of Bristol Street. Alfred E. Hawley, a sporting-goods dealer, came to Santa Ana in 1887. In 1906, in part to boost sales of his sporting equipment, he built the park and then sponsored a team, the Santa Ana Stars, to play at his ball field. It quickly became one of the most popular places to watch baseball in Orange County. Walter Johnson pitched here many times, and where there was once baseball, a neighborhood occupies the site today.

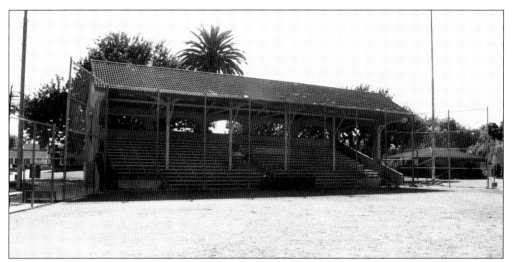

Anaheim's Pearson Park (originally called Anaheim City Park) has hosted baseball since the grandstand was built in 1927. On September 20, 1920, city trustees approved the purchase of Herman A. Dickel's 19-acre ranch at the southwest corner of Lemon and Sycamore Streets. A man named Rudy Boysen was hired to supervise installation and maintenance of the park. For almost 40 years, Boysen oversaw the park, and he even found the time to develop the now well-known boysenberry. Today at the park, the maintenance buildings, which were originally part of Boysen's greenhouse, still stand.

The grandstand, which has been rebuilt since 1927, sits at the exact same spot as the original and has been redesigned to resemble the first grandstand. Anaheim police chief Randy Gaston, who led a major restoration of the park in 1999, died while jogging near this structure. To honor him, the city planted an oak tree and placed a plaque on the side of the grandstand. Of note, an infamous Ku Klux Klan rally was held at this park in 1924. That year, before the rally, Anaheim had unwittingly elected four Klansmen to the city council. One year later, a successful recall election had them replaced.

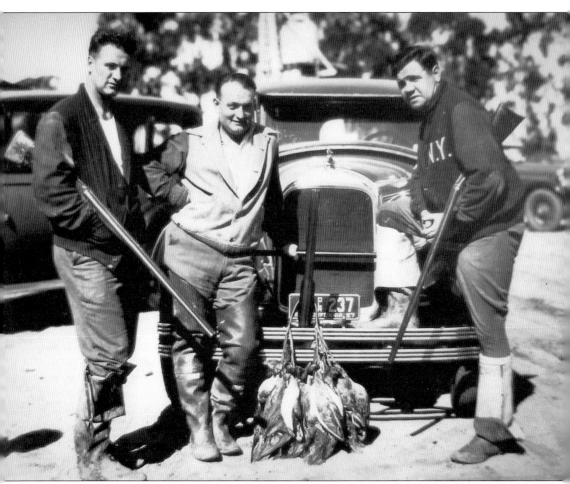

In 1927, two of the greatest names in baseball history visited Orange County. Here, Babe Ruth (right) is pictured with teammate Lou Gehrig (left) and well-known local car dealer Glenn Thomas. Thomas's car dealership is still in business today. Before passing away, Thomas told associates that he invited the Yankee stars to join him for a day of hunting at a private gun club he belonged to in the city of Cypress within Orange County. The club is long gone, replaced by the Los Alamitos Race Course, but evidence of their experience remains with this rare photograph.

Three
"A Monster Athletic Contest"

BASEBALL!

Walter Johnson
Pitching for the Anaheim Elks

vs.

Babe Ruth
Pitching for Ruth All-Stars

KEN WILLIAMS　　　　　TUFFY TYRELL
ERNIE JOHNSON　　　　JIMMY AUSTIN
BOB MEUSEL　　　　　　RUBE ELLIS
HARVEY McCELLAN　　　SAM W. CRAWFORD
AND OTHER MAJOR LEAGUE STARS

Brea Bowl
BREA, CALIFORNIA

Friday, 2:30 p.m., Oct. 31

Only Game in Southern California Where Johnson and Ruth Oppose Each Other. Auspices Anaheim Elks, No. 1345

Pictured here is an ad in the *Fullerton Tribune* newspaper promoting the now-legendary game that featured "local boy made good" Walter Johnson returning home to lead the Anaheim Elks team against the Babe Ruth All-Stars, headed by Babe Ruth himself. An *Anaheim Bulletin* headline read, "All roads lead to Brea for Monster Athletic Contest."

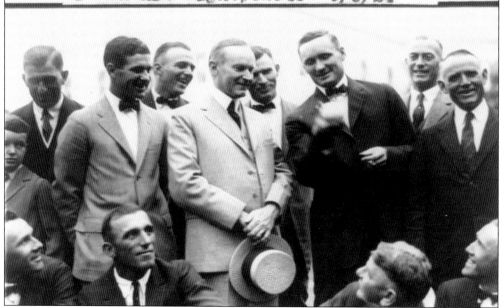

Just the month prior to returning home to pitch in Brea, Walter Johnson shows Pres. Calvin Coolidge how to throw a curveball. Washington Senators player/manager Bucky Harris is standing to the immediate left of Coolidge.

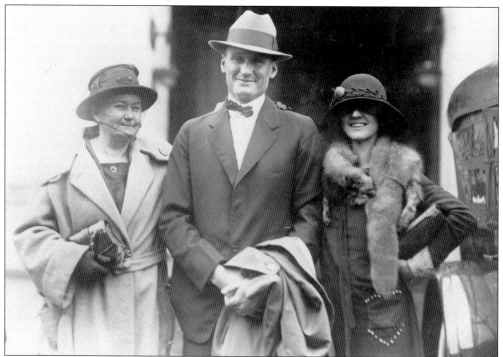

Walter Johnson is pictured here on October 1, 1924, a month before returning home to pitch in Brea. His mother, Minnie, is on the left, and his wife, Hazel, is on the right.

The well-known sculptor Ulrich Stonewall Jackson Dunbar sketches Walter Johnson for a sculpture he will create soon after. The date is October 2, 1924, less than a month before Johnson returns home to pitch in Brea. The location is Griffith Stadium in Washington, DC, then home to Johnson's team, the Washington Senators.

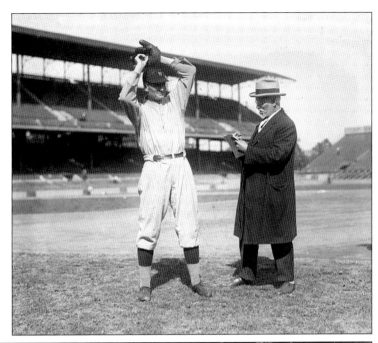

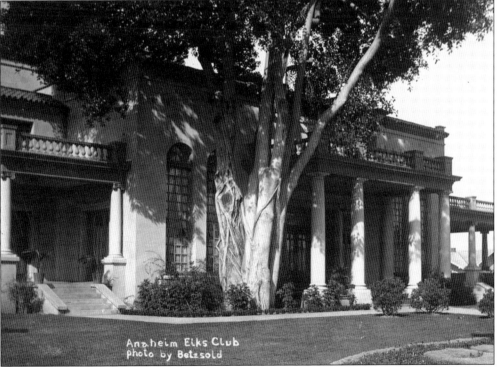

The night before the game, October 30, Walter Johnson was the guest of honor at the Anaheim Elks Club (the game was sponsored by the Elks). This is a close-up view of the front facade of the Anaheim Elks Club building, which was located at 423 North Los Angeles Street (now Anaheim Boulevard) and Sycamore Street. The building has since been torn down, and today an auto-parts store is at the site.

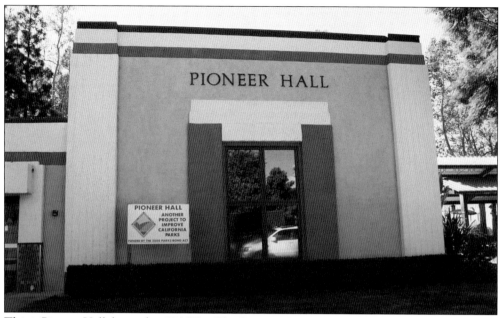

This is Pioneer Hall, located at 304 West Elm Street in Brea. Now part of the city's senior citizen complex, in 1924 it was located adjacent to the Brea Bowl, and all of the players at the game were hosted at a pregame pancake breakfast in this building before some of them took part in the Halloween parade preceding the game (the first time the now-traditional Brea Halloween Parade was ever held).

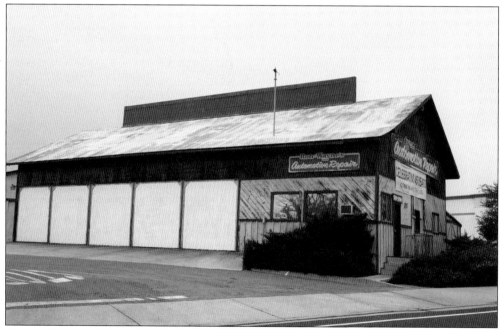

The building that houses this auto-repair shop is one of the few structures in the area that was standing when the game took place. Located just a short walk from the Brea Bowl, this is where the players changed into their uniforms before making their way down to the field, where an eager crowd awaited their arrival.

Walter Johnson of the Washington Senators and Babe Ruth of the New York Yankees hold a baseball bat together during the famous barnstorming charity baseball game, which was sponsored by the Anaheim Elks Club and played in Brea on October 31, 1924. It was not the last time these two legends would appear together in a high-profile exhibition game, but it was certainly one of the most memorable.

This group portrait shows Johnson posing with some of his former Olinda teammates and managers at the exhibition game at the Brea Bowl. By this point in his career, Johnson had not played with these men for about 15 years; however, he was the only one still playing baseball.

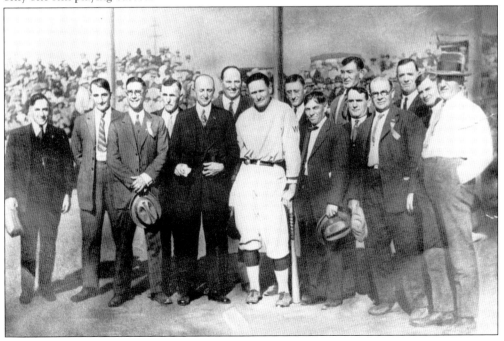

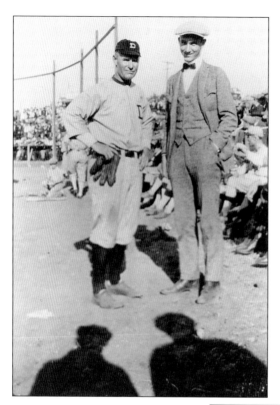

Sam Crawford poses with photographer George Outland. From 1921 through 1930, Outland, who would go on to be a professor and US congressman, documented his love for baseball by arriving early at major-league and Pacific Coast League (PCL) ball games armed with his camera and an album of his own photographs. He used his skills to gain access to some of the greatest players and ballparks of his era, and his subjects included such legends as Walter Johnson, Paul Waner, Sam Crawford, Babe Ruth, and many more. His photographs in this book, generously supplied by Outland's son John W. Outland, are perhaps the most rare images of this game. (Courtesy of John Outland.)

Legendary Dead Ball–era player Sam Crawford, also a good friend of Walter Johnson, took part in the game. Combining a powerful stroke and blazing speed, it was with the triple that "Wahoo Sam" made his mark as he set the major-league record with 309, leading the league six times. Crawford was elected to the Hall of Fame by Veterans Committee in 1957.

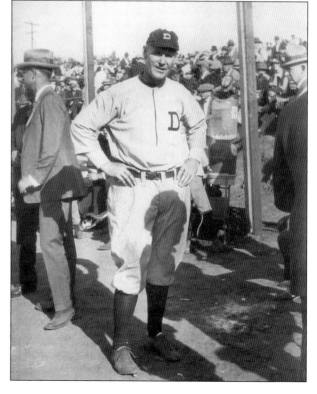

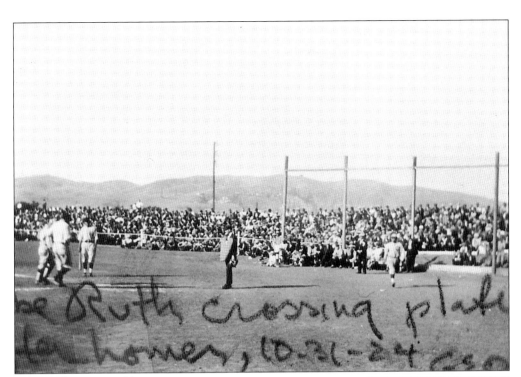

Babe Ruth is pictured here in an Outland photograph crossing home plate after hitting one of his two home runs in the game, which were pitched by Johnson. (Courtesy of John Outland.)

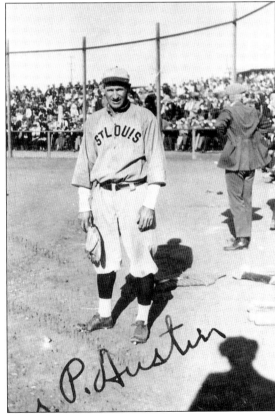

Another star playing this day in Brea, photographed here by Outland, was Jimmy Austin. Born in Wales, Austin was one of the best third basemen of his era. The switch-hitting chatterbox is most famous for a photograph of him at third base, attempting to avoid the flying spikes of Ty Cobb. Austin eventually settled in Laguna Beach, Orange County, and is buried in Anaheim. (Courtesy of John Outland.)

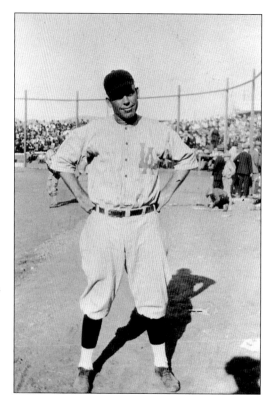

George William "Rube" Ellis stole 25 bases as the Cardinals' regular left fielder in 1910. Just before his death in 1938, he was an unsuccessful candidate for secretary of the Association of Professional Ball Players of America. He was one of the many stars to grace the field in Brea on October 31, 1924, and have a photograph taken by George Outland. (Courtesy of John Outland.)

Walter Johnson, local Olinda boy made good, poses for photographer George Outland. The day after this image was captured, Johnson returned to the nearby oil fields in Olinda to reconnect with some of his old friends. It was the last time he would ever visit the area. (Courtesy of John Outland.)

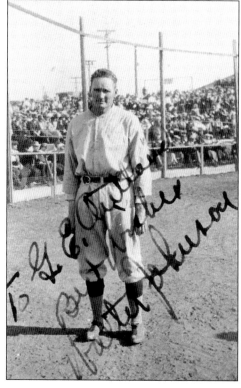

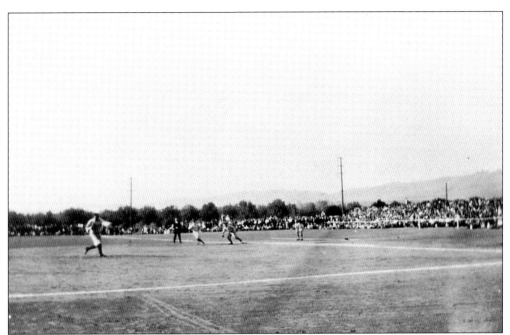

The standout pitcher of the game, ironically, was not Walter Johnson; it was Babe Ruth, who had not pitched in three years. Ruth, the former star left-hander of the American League, took a shutout into the ninth until his Yankee teammate and friend Bob Meusel took him deep. Ruth gave up six hits total in a 12-1 complete-game win over the team led by Johnson. Ruth is seen here on the mound in this rare photograph taken by George Outland. (Courtesy of John Outland.)

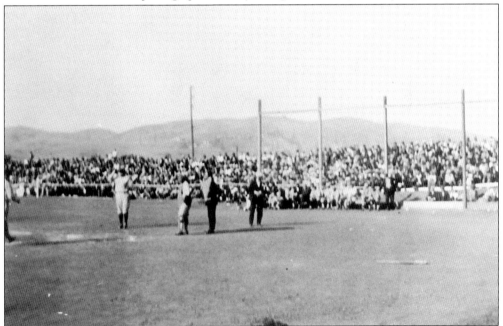

This is another interesting Outland image. Sam Crawford (far left) crosses the plate after homering off of Walter Johnson in the 12-1 romp. Crawford's teammate Babe Ruth is seen standing near home plate on deck (left of the catcher), waiting to greet Crawford. (Courtesy of John Outland.)

Today, the area where the game was played, the former site of the Brea Bowl, has been completely developed and bares no signs of a ball field. How many of the residents know that Babe Ruth, Walter Johnson, Sam Crawford, Bob Meusel, and other players may have been standing exactly where their cars are parked or where the garbage cans are dragged out to each week?

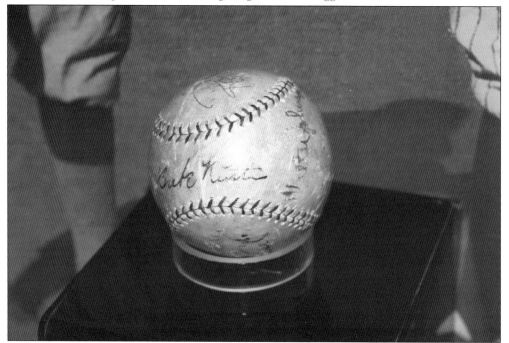

At the Brea Museum and Heritage Center, there is a permanent exhibit dedicated to the memorable game at the Brea Bowl. It includes rare photographs and this treasure, a ball signed by Babe Ruth, Walter Johnson, and other players from the game.

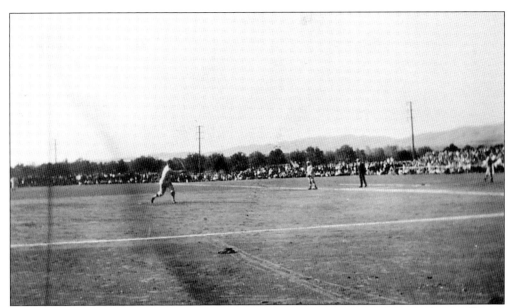

Walter Johnson pitches in Brea on October 31, 1924. "Bus" Callan, who had caught at Fullerton High a few years earlier and now played for the Union Oil team on weekends, was quoted 50 years after the game saying, "I used to be a pretty good catcher, but I was rusty by then. Honestly, when he threw in some of those fireballs, I couldn't see them. We had a short conference at a spot between home plate and the pitcher's mound, and I said, 'Walter, I just can't see the ball.' He replied, 'Just put your mitt where you want me to throw and I'll throw into it,' and he did!"

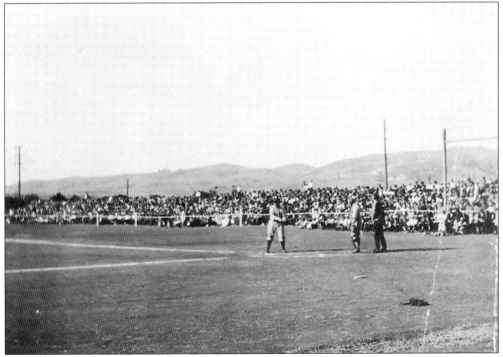

Babe Ruth bats in Brea, one of the rare images captured by George Outland on this day. Visible in the background are the hills near Olinda where Walter Johnson grew up.

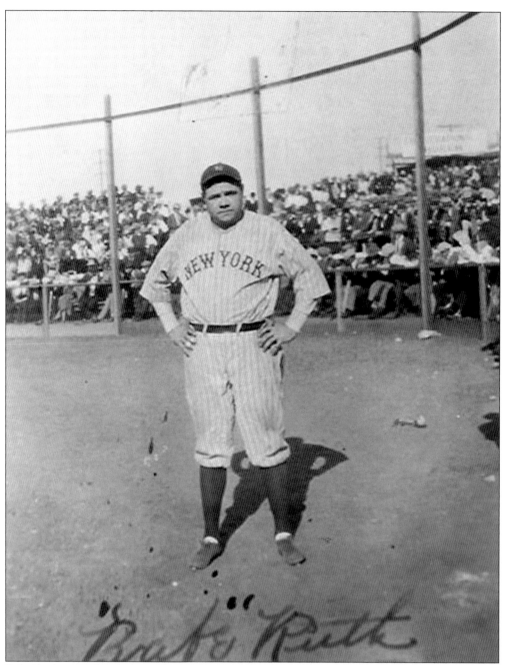

Babe Ruth poses for photographer George Outland in Brea on the day of the big game. In 1924, Ruth's barnstorming tour took him and his All-Star team all along the West Coast, culminating in this game against a team led by Water Johnson and local Orange County players. One of the five local Anaheim players on Johnson's team that day was Vic Ruedy. Interestingly, Ruedy went on to become the parks superintendent for the City of Anaheim, and it was under his jurisdiction that Anaheim Stadium, home of the major league Angels, opened in 1966.

Four

LIONETTES, VALENCIAS, LOS JUVENILES, AND SOME BIG STARS

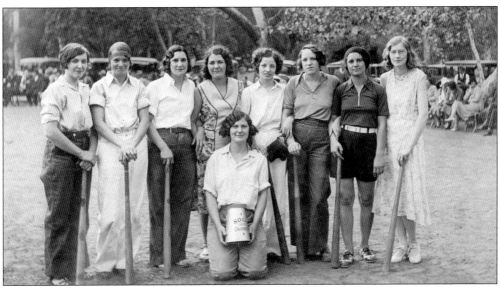

This is the Santiago Orange Growers Association women's champion baseball team of Orange, California, in 1931. Like oil companies, citrus growers also sponsored leagues, and players from this team, posing with their championship trophy at Irvine Regional Park (known as Orange County Park until 1928) were employed by the Santiago Orange Growers Association, located at the corner of West Palm Avenue and North Cypress Street in Orange, California. (Courtesy of Orange Public Library.)

As John Weyler wrote in the *Los Angeles Times* in 1998, "The economy was starting to make a comeback, so Elsie Cox and Betty Bergen, a couple of enterprising Orange High students, figured they could squeeze a few sponsorship bucks out of the fellows down at the local Lions club. After all, there was no way a bunch of high school kids were going to come up with the $5 it cost for softball uniforms in 1936." And so the Orange Lionettes, one of the most successful softball franchises in history, was formed. This team photograph is from 1950. (Courtesy of the Orange County Archives.)

Within just two years, the Lionettes won their way into the Southern California championship game. They had become fast-pitch stars a full decade before female baseball players would form the renowned All-American Girls Professional Baseball League teams during World War II.

The Lionettes won their first national championship in 1950 and would go on to win eight more titles over the next 20 years. The team was a major force in the development and promotion of their sport. When the International Women's Professional Softball (IWPS) League was formed in 1976, the team joined as the Santa Ana Lionettes. The Lionettes' decision to turn pro gave instant credibility to the pro softball league. Unfortunately, due to financial losses and philosophical differences, the Lionettes played only the first two seasons in the league. In 1979, the franchise relocated to White Plains, New York.

The Orange Lionettes played home games at Hart Park in Orange, starting their first season there before the park was even finished being built; the park was a 1935–1936 City of Orange/Works Progress Administration (WPA) project. The field remains, though the old bleachers have been replaced.

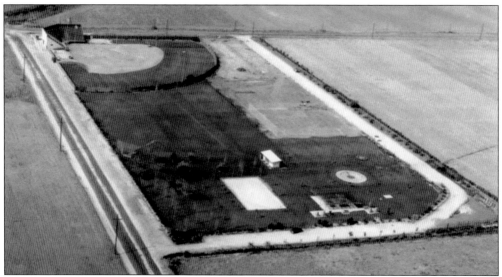

This is George Bellis Park in Buena Park in the 1940s. Back then it was simply called Buena Park Recreation Park, and it was here where the Buena Park Lynx, a then-popular women's fast-pitch softball team, made their run at a national championship (the team's farm club, the Buena Park Kittens, also called this park home). Today, at the Whitaker-Jaynes Estate and the Bacon House Museum there is an exhibit dedicated to the team. The park still exists, though all of the open land has since been developed. (Courtesy of the Buena Park Historical Society.)

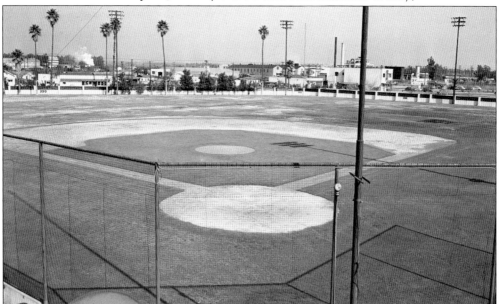

The idea for La Palma Park in Anaheim goes back to 1937 when the city council asked the federal government for money to build a park. The WPA provided the funds, along with 63 workers. Construction began on December 16, 1937, and by March 1939 the baseball field was ready for use. Anaheim held a naming contest, and La Palma, Spanish for "the palm," won. The first baseball game at the park was on March 12, 1939; it was a PCL spring-training game between the Seattle Rainiers and the Sacramento Senators. Sacramento trained at La Palma that spring and played 10 games there. Fans could either purchase a season-ticket book for $3.50 or pay 35¢ a game.

Besides baseball and football, the stadium has played host to soccer games, rodeos, a circus, high school graduations, and the annual Anaheim Halloween Parade. Jackie Robinson portrayed himself when *The Jackie Robinson Story* was filmed here in 1950; the movie also starred Ruby Dee and Minor Watson.

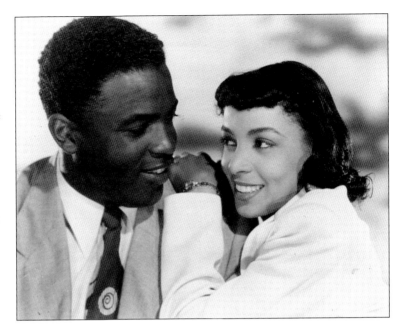

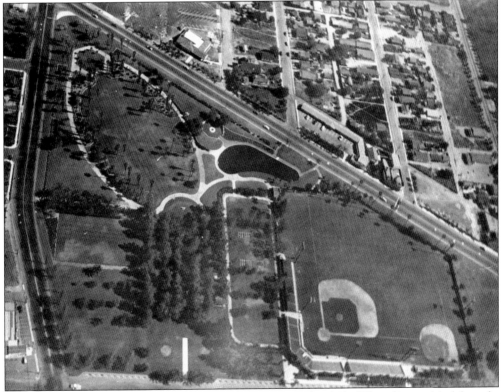

This is La Palma Park (lower right) as it looked from the air in the 1940s. When Connie Mack brought his Philadelphia Athletics here in February 1940, the team stayed at the Angelina Hotel. Mack was quoted as saying, "This is the greatest setup my club has ever had in a training camp."

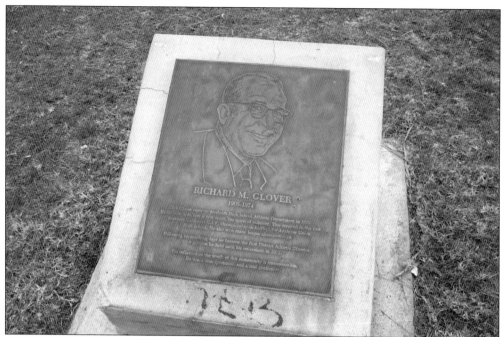

The park has been renamed twice. In 1971, it was changed to Glover Stadium after Richard Glover, who was an assistant and head football coach at Anaheim High School from 1931 to 1957.

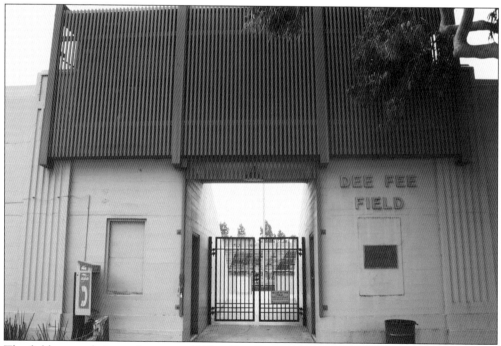

The field was rechristened again in 1987 as Dee Fee Field, in honor of Dee Fee, who worked in several positions for the Anaheim Parks Department from 1937 to 1987.

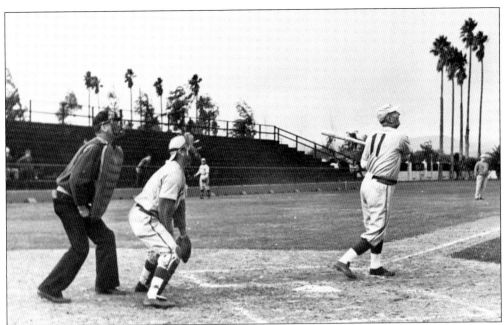

A group of fans in Anaheim persuaded the Philadelphia Athletics, led by the venerable Connie Mack, to spend the spring of 1940 in the city. Mack brought his team west, using the Angelina Hotel as camp headquarters, with some players also staying at the Pickwick and Valencia Hotels. The Athletics wanted to return to Anaheim after World War II, but a shortage of hotel rooms and housing negated their plans, and they never returned.

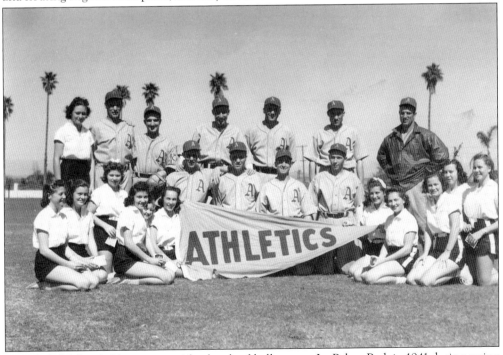

The Philadelphia Athletics pose with a local softball team at La Palma Park in 1941 during spring training in Anaheim.

This is La Palma Park as it looks today. Connie Mack had a deep fondness for the area and in particular for this park, which was, according to him, the best facility his team played at for spring training.

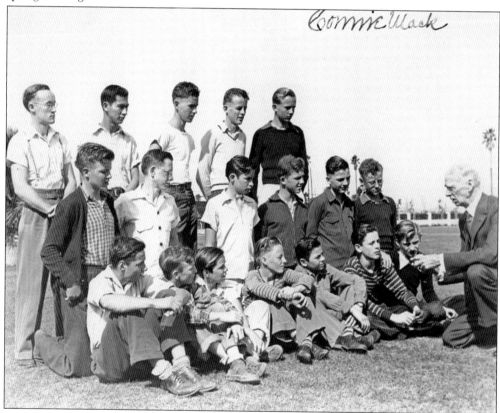

Famed Philadelphia Athletics manager Connie Mack (born Cornelius McGillicuddy) is seen giving a baseball clinic to a group of young baseball fans during spring training in 1941 at La Palma Park. By all accounts, Mack was gracious and approachable during his two spring seasons in Anaheim.

This image shows Earle Mack (left) and Charlie Berry, coaches with the Philadelphia Athletics, in Anaheim for spring training in 1941. The photograph is signed by both players to George Hedstom, teacher of chemistry and physics at Anaheim Union High School for 40 years.

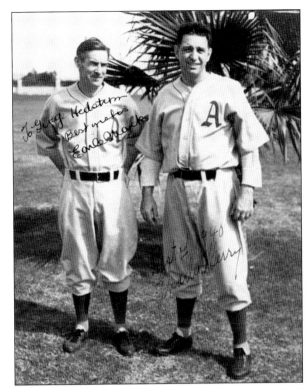

Jimmie Heffron, an *Anaheim Bulletin* sports editor, interviews Luke Sewell, manager of the St. Louis Browns, during spring training in March 1946 at La Palma Park.

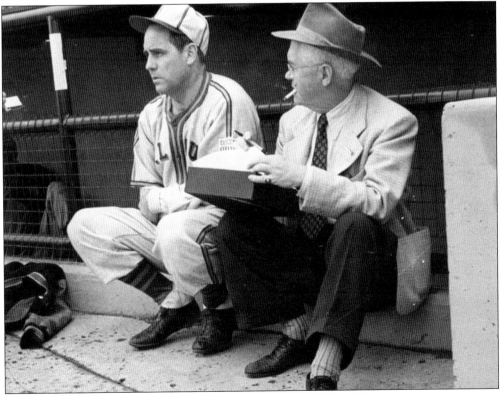

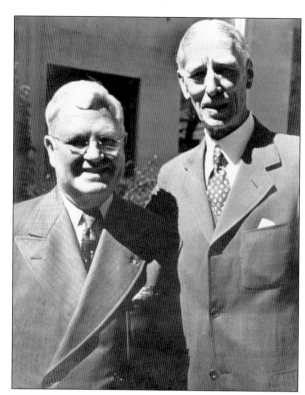

This is a picture of Anaheim Union High School principal Joseph Clayes (left) and Connie Mack, manager of the Philadelphia Athletics (1901–1951), taken at La Palma Park during spring training in 1941.

Connie Mack (seated, center) returned to La Palma Park in Anaheim, where he had his Philadelphia Athletics in training more than 10 years earlier. With him are first baseman Chuck Stevens (left) and Mack's cousin Ralph Gutgsell (right); Bob Clements of the Hollywood Stars is sitting behind Mack. This image is dated March 9, 1954.

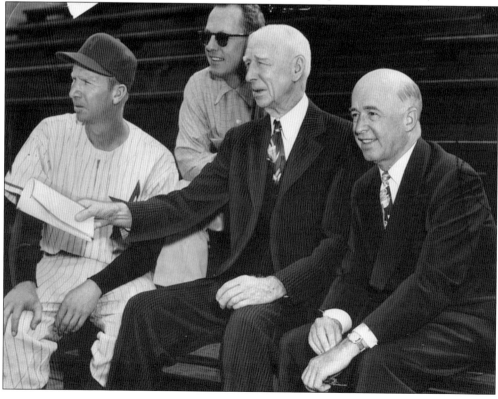

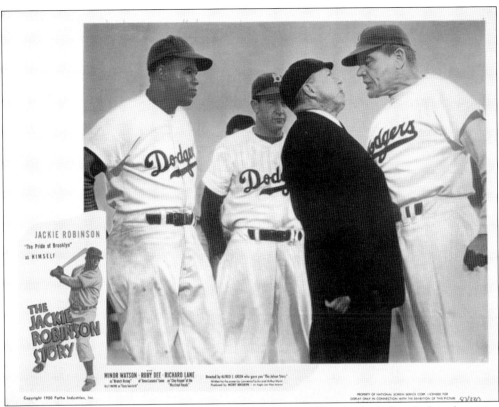

This is a lobby card from the 1950 *The Jackie Robinson Story*, filmed at La Palma Park and starring Jackie Robinson as himself.

The Anaheim Valencias, named for the sweet local oranges, formed in 1947 and played in the Sunset League, a Class-C team affiliated with the Sacramento club in the old PCL. The Sunset League, comprised of teams from Anaheim, Riverside, Ontario, El Centro, Las Vegas, and Reno, operated from 1947 through 1950. The Valencias won the league championship in 1947 and played at La Palma Park.

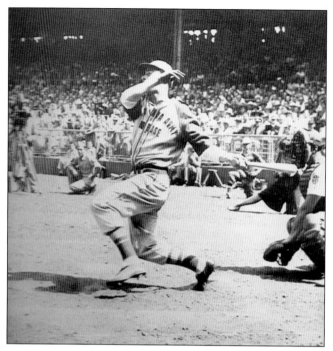

New York Yankee legend Joe DiMaggio enlisted in the US Army Air Forces on February 17, 1943, and was assigned to Special Services. He reported for duty on February 24, 1943, to Santa Ana Army Air Base in Costa Mesa. Naturally, DiMaggio was a huge boost to the Santa Ana Air Base company baseball team, but he did not explode out of the gate. In his first game, DiMaggio went hitless against the Fullerton Junior College baseball team. Here, wearing his Santa Ana Army Air Base uniform, DiMaggio displays his classic follow-through at the plate during a game at Wrigley Field in Los Angeles.

The Santa Ana Air Base team was an incongruous collection of semipros, minor leaguers, and teenagers who had never really played much baseball before. At first and second base were Dick and Bobby Adams, respectively—brothers who both played major-league baseball after the war. With DiMaggio at the helm, the Santa Ana team built a strong record that included a 20-game winning streak. DiMaggio himself put together a 27-game hitting streak. Here, DiMaggio chats during a break at La Palma Park.

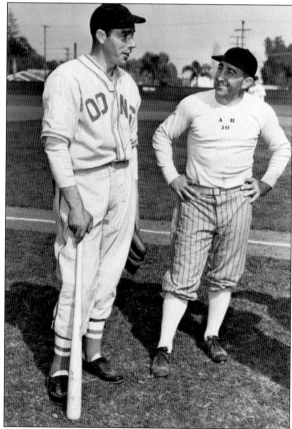

Joe DiMaggio bats for the Santa Ana Army Air Base baseball team in a game versus the Los Angeles Angels of the PCL on April 13, 1943. The catcher is Billy Holm. The Angels won with a final score of 6-5.

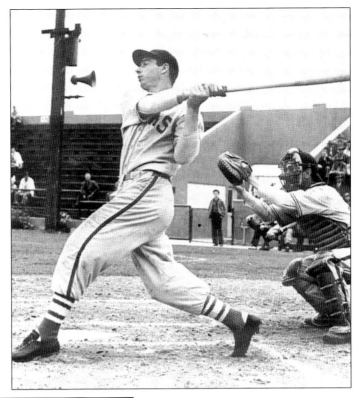

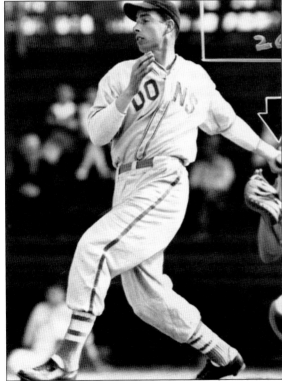

Joe DiMaggio, wearing the uniform of the Santa Ana College Dons, is seen playing baseball in Anaheim at La Palma Park while stationed at the nearby Santa Ana Army Air Base in 1943.

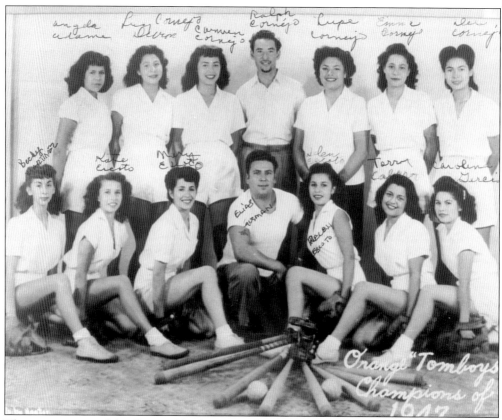

This is a portrait of the Orange Tomboys, an all-female baseball/softball team, in 1947. Based in Orange, California, this team was organized by Elias Guzman. The players were Mexican American and they played other Mexican American female teams from surrounding cities, such as Placentia, Anaheim, Santa Ana, Westminster, and La Habra. They were league champions in 1944. (Courtesy of Richard Santillan.)

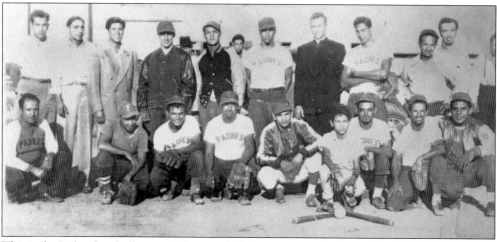

This is the Padres baseball team of Orange, California, in 1948. The Padres were a neighborhood men's team from the North Cypress Street barrio in Orange, California. They played all around Orange County. (Salvador Felix is the batter.) (Courtesy of Richard Santillan.)

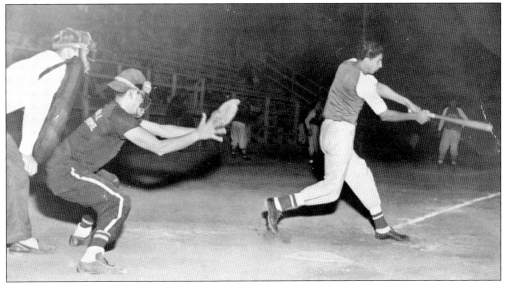

This 1946 image shows the Padres baseball team in Orange, California. The Padres traveled to other regions and played other barrio teams. When playing locally, their home was an open field located on West Walnut Avenue, west of the railroad, in Orange. Money gathered through general collections and concession stands went towards purchasing equipment. (Courtesy of Richard Santillan.)

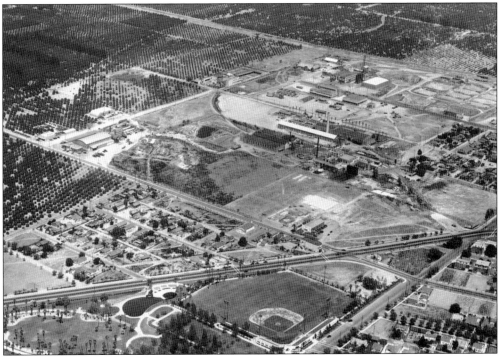

This is La Palma Park as it looked when the Anaheim Aces, a charter member of baseball's California League, played here in 1941. At the Class-C level, the minor league's other teams included the Bakersfield Badgers, Fresno Cardinals, Merced Bears, Riverside Reds, San Bernardino Stars, Santa Barbara Saints, and Stockton Fliers. The Aces folded after the 1941 season, when America entered World War II.

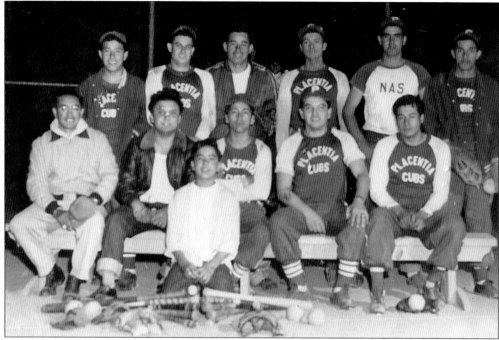

These are the Placentia Cubs, a softball that played at Kraemer Park in Placentia. On the far left is coach Gualberto J. Valadez, for whom today a school is named in the Placentia/Yorba Linda School District. (Courtesy of Richard Santillan.)

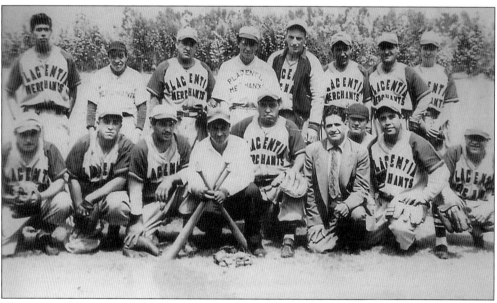

This is a c. 1943 image of the Placentia Merchants. Tommy Munoz, the manager (or coach) of the team seen holding the bats in the front row, was instrumental in working with many other Mexican teams in Orange County throughout the years. Champions Field, in Placentia, was dedicated to Munoz and today remains as Munoz Field. (Courtesy of Richard Santillan.)

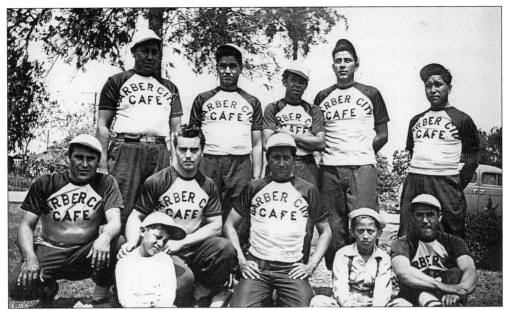

Pictured here is the Barber City Café team. The squad represented the barrio off of Highway 39 (now Beach Boulevard) in the area once known as Barber City (today part of Westminster). (Courtesy of Richard Santillan.)

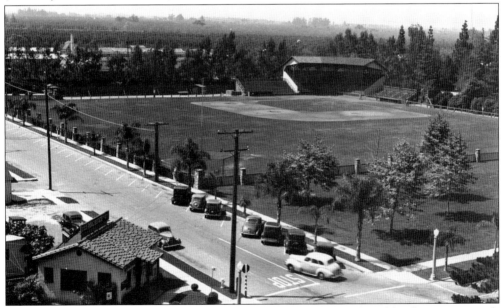

Amerige Park, located at the southwest corner of Commonwealth and Highland Avenues, stands on the site of the old Fullerton High School. Built in the 1930s, it served as the spring-training grounds for PCL teams, including the Hollywood Stars (1935), San Diego Padres (1936), Portland Beavers (1937–1940), Sacramento Solons (1941–1942 and 1944), and the Los Angeles Angels (1946–1955; no relation to the Anaheim Angels). Stars such as Joe DiMaggio (along with his brothers Dom and Vince when all three brothers played for the San Francisco Seals), Satchel Paige, Rogers Hornsby, Ted Williams, Gary Carter, Arky Vaughan, and Bob Lemon all played on this field. (Courtesy of Fullerton Public Library.)

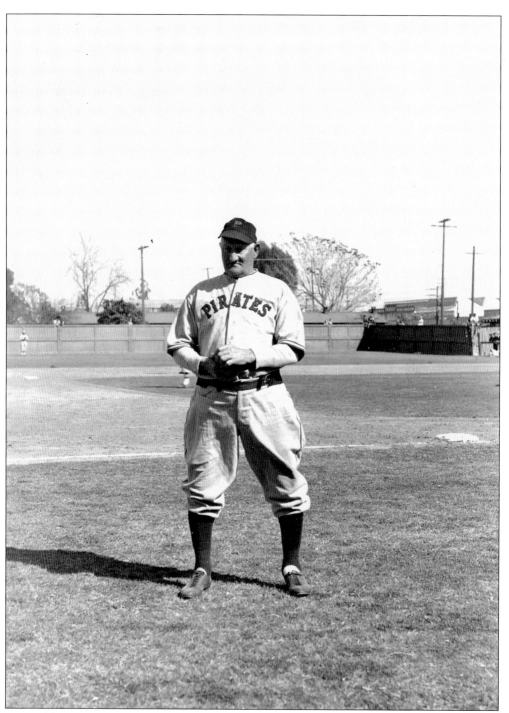

Pictured here is Hall of Famer Honus Wagner. After his playing days with the Pittsburgh Pirates ended, the legendary shortstop coached the team from 1933 to 1951. In this rare image from the mid-1930s, Wagner is seen at Amerige Park on a day when the Pirates traveled from the spring-training facility in San Bernardino to play an exhibition game in Fullerton. (Courtesy of Fullerton Public Library.)

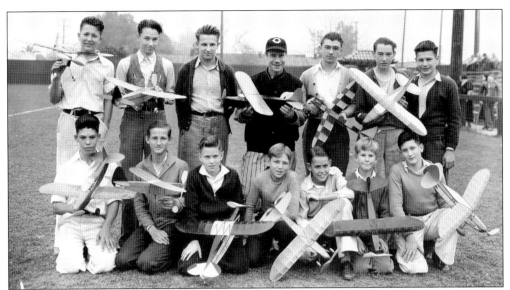

In the late 1920s, Fullerton resident George McClelland founded the Fullerton Hawks Model Aircraft Club for teenagers, who enjoyed studying flight as much as he did. The club was so popular, even Adm. Richard E. Byrd considered himself a member and would review the club's models. They would fly occasionally at Amerige Park. During the filming of *Alibi Ike*, actor and comedian Joe E. Brown (with the ball cap) had a photograph taken with the club. (Courtesy of Fullerton Public Library.)

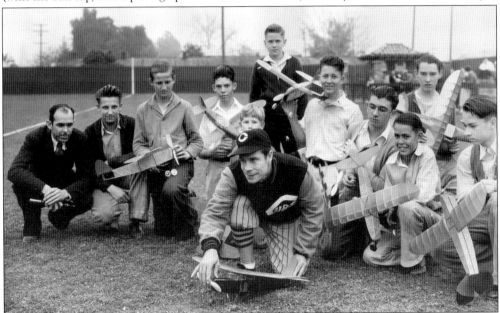

This is another photograph of Brown with the aircraft club. At right, in the background, is the main entrance to Amerige Park, a pagoda-shaped structure with a tile roof. Coincidentally, Brown later became part owner of the Pittsburgh Pirates. In 1951, additional grandstands were constructed at Amerige. By this point, the park was also used for high school and college games. This is where the California State University, Fullerton Titans played before Goodwin Field was built on campus. In the 1960s, youth league teams moved in (PCL spring training was long gone), and Amerige Park was used for soccer games. (Courtesy of Fullerton Public Library.)

In 1935, Amerige Park was the site of a major motion picture, *Alibi Ike*, starring Joe E. Brown as a baseball player. This is a production still during the filming; Brown is indicated with an arrow on the pitcher's mound. As the film's press kit described, "Baseball rookie Frank X. Farrell is a phenom, a kid who can hurl the ol' horsehide and swing the lumber so well he may lead Chicago's beloved Cubbies to a pennant." Pro players Bob Meusel and Jim Thorpe, among others, also appear in the film, as does "a charming newcomer," according to Frank S. Nugent in the *New York Times*, by the name of Olivia de Havilland. (Courtesy of Fullerton Public Library.)

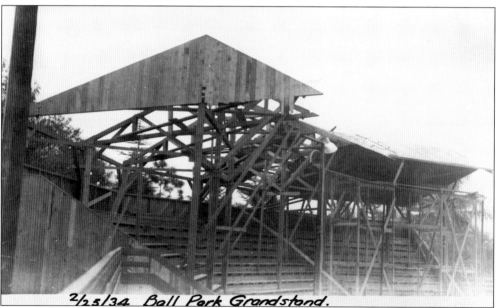

In this photograph dated February 25, 1934, the first grandstand is being constructed behind home plate at Amerige Park, part of a major WPA project. Anaheim High School began playing here in 1933, and a year later, thanks to businessman and baseball fan Charles McGaughy, the covered grandstand and outfield fences were being constructed. This was now known as Commonwealth Park. (Courtesy of Fullerton Public Library.)

By March 28, 1934, the grandstand at Amerige Park nears completion. The first full-time, organized team to play at the park was sponsored by Orkins Department Store (the team was usually referred to as the Fullerton Merchants). They played their debut game here on April 25, 1932. (Courtesy of Fullerton Public Library.)

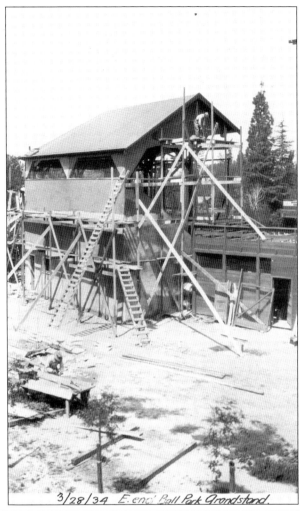

Pictured here is the front entrance to Amerige Park not long after it opened in the mid-1930s. As to who Theron Wilson is, a page from the Fullerton High School class of 1924 yearbook reads, "Theron Wilson has ended his last year of tennis for Fullerton. Never before has he displayed as fine a brand of tennis as he has this year. Theron was the backbone of our tennis team and on many occasions his playing added impetus to the game of his teammates." (Courtesy of Fullerton Public Library.)

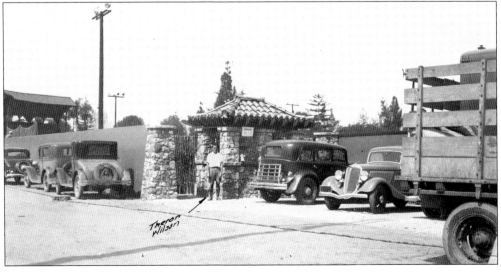

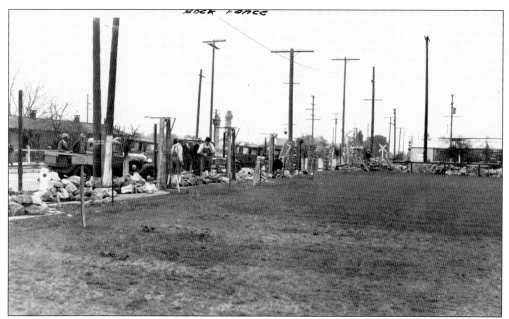
Starting in 1934, what was then called Commonwealth Park became a WPA project. Part of the undertaking included flagstone and mortar pillars, called "pilasters," that surrounded the entire park. (Courtesy of Fullerton Public Library.)

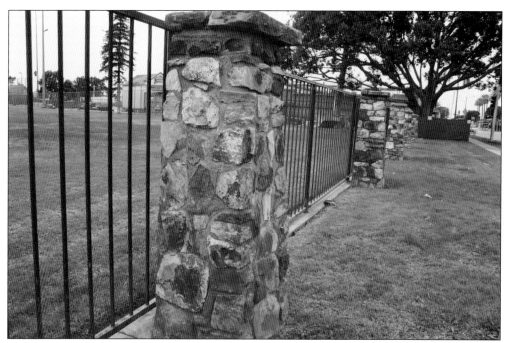
Today, the pilasters remain, though most of the other WPA structures have been removed over the years. The grandstand was completely replaced in the 1980s after a fire destroyed what was then left of the historic grandstand. (Courtesy of Fullerton Public Library.)

The left-field view shows a packed house watching baseball at Amerige Park in the late 1930s. (Courtesy of Fullerton Public Library.)

In this alternate angle from the right-field corner is a late 1930s view of a capacity crowd at Amerige Park. The Vancouver Mounties played here in 1956, their first year in the Pacific Coast League, and the San Francisco Seals were the last PCL team to be based here, in 1957, which was their last year of existence before the National League came to Los Angeles and San Francisco. (Courtesy of Fullerton Public Library.)

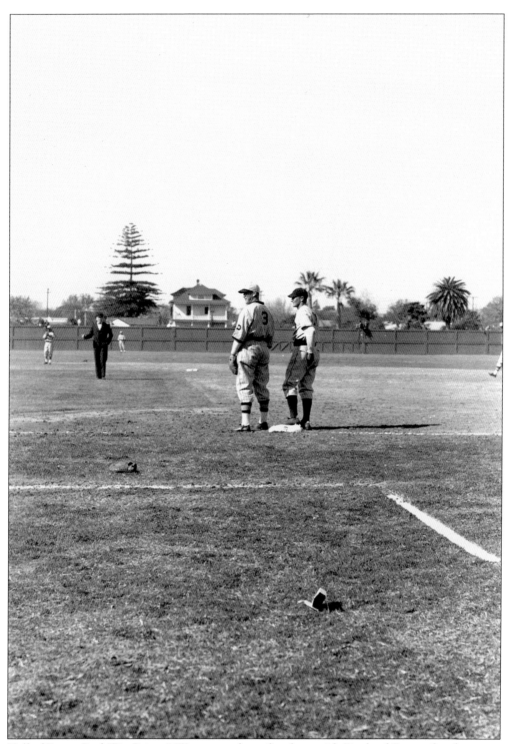
Hall of Famer Paul "Big Poison" Waner stands on first base with Portland Beaver first baseman Bill Sweeney during a March 31, 1938, spring-training game at Amerige Park between Portland and the Pittsburgh Pirates. (Courtesy of Fullerton Public Library.)

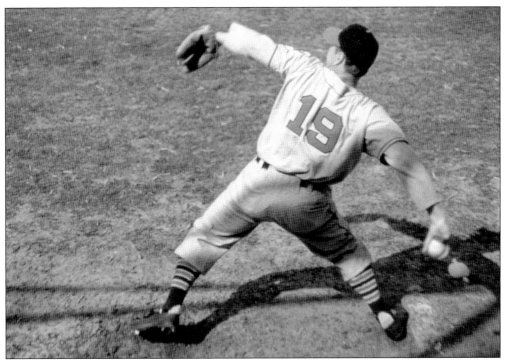

Cleveland Indians ace and future Hall of Famer Bob Feller pitches at Amerige Park during a 1949 spring-training game.

Amerige Park was rededicated on July 18, 1989. The grandstands, ticket booths, and fences are seen here all new. The field itself is now named for former Fullerton mayor and city councilman Duane Winters. Most recently, Amerige Park has been home to the Fullerton Little League Junior Division and Pony Colt League. (Courtesy of Fullerton Public Library.)

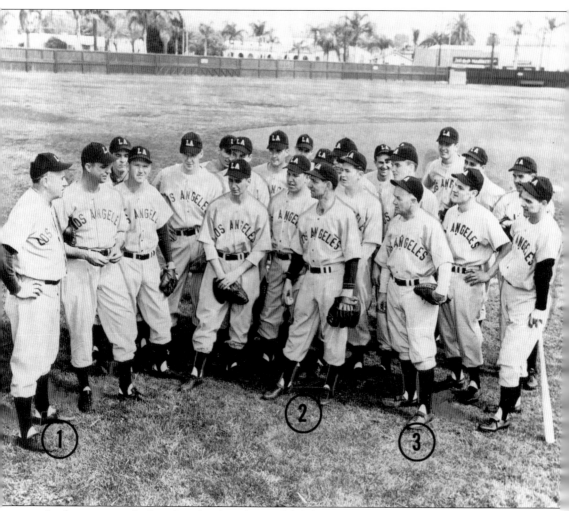

In this image is the Los Angeles Angels squad (of the PCL, no relation to the team that would eventually move to Anaheim in 1966) at spring training at Amerige Park in Fullerton. Rookies and a few veterans gather around with Angels manager Bill Kelly (1) and coaches Jack Warner (2) and Jigger Statz (3). (Courtesy of Fullerton Public Library.)

Five

THE CALIFORNIA ANGELS ARRIVE

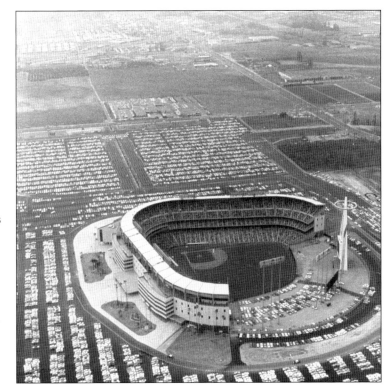

Angel Stadium has been the home of the Angels since their move to Orange County from Los Angeles. In 1964, construction began for Anaheim Stadium, and in 1966 the California Angels moved to the site after having spent four seasons renting Dodger Stadium (named Chavez Ravine Stadium during Angels games) from the Dodgers. This image is from 1966, the stadium's inaugural year.

This is the future site of Angels Stadium in 1964. The Angels franchise started in 1961, playing their first season in Wrigley Field, a 20,500-seat minor-league ballpark in Los Angeles that was home to the original Los Angeles Angels of the PCL.

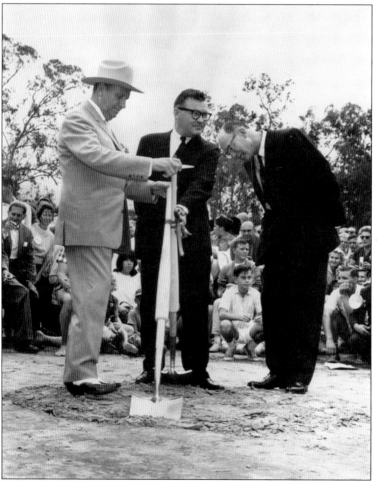

The historic ground-breaking for Anaheim Stadium took place on August 31, 1966, with Angels personnel, City of Anaheim officials, and a large turnout of fans on hand. Seen participating in shovel ceremonies are, from left to right, Angels chairman of the board Gene Autry, Anaheim mayor Odra Chandler, and contractor Del Webb. The shovels had baseball bat handles. This photograph is dated January 22, 1966.

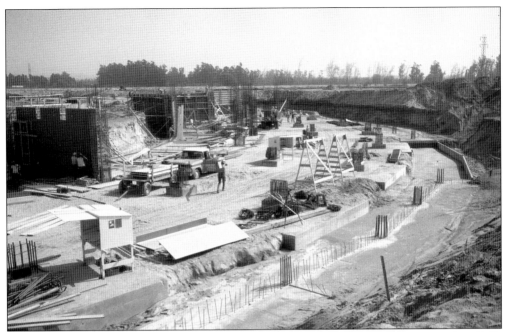

This is the Angels Stadium construction site in 1965. When Dodger Stadium opened in 1962, the Angels signed a four-year lease to play there. The Angels paid the Dodgers 7.5 percent of gross attendance revenues for rent, along with 50 percent of the Angels' concession gross and all parking revenues. Angels owner, famed cowboy/actor Gene Autry, did not want to play second fiddle to the Dodgers, so he looked to move to the suburbs. (Courtesy of Tom Duino and Richard Wojcik.)

The Angels almost settled in Long Beach, but negotiations ultimately broke down when the city insisted the team had to be called the Long Beach Angels. Autry chose Anaheim, even though at the time it only had a population of 150,000. However, seven million people lived within 50 miles of the ballpark site, which was 140 acres of land previously taken up by four farms. There, Autry's team could be called the California Angels. (Courtesy of Tom Duino and Richard Wojcik.)

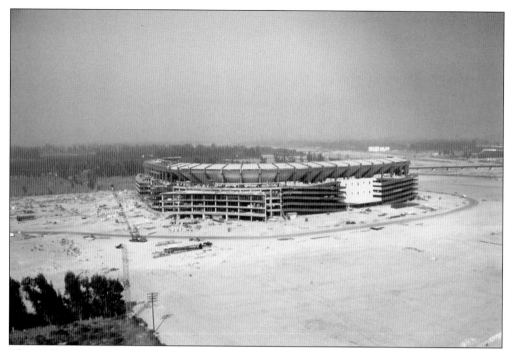

The stadium is seen taking shape in 1965. Construction began on August 31, 1964, and despite a work stoppage and strikes, Anaheim Stadium was completed in time for opening day in 1966 at a cost of $24 million. Note the farmland still surrounding the stadium back then. Today, the area is completely developed. (Courtesy of Tom Duino and Richard Wojcik.)

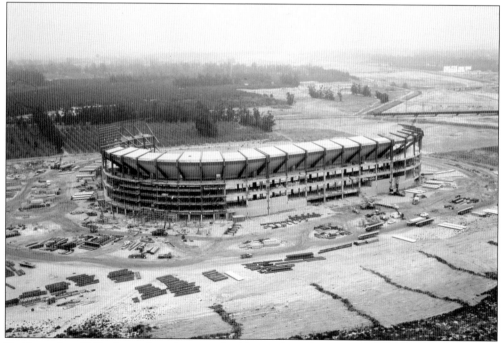

By November 1965, the parking-lot areas had been cleared around the stadium, and the basic shape and design was in place. (Courtesy of Tom Duino and Richard Wojcik.)

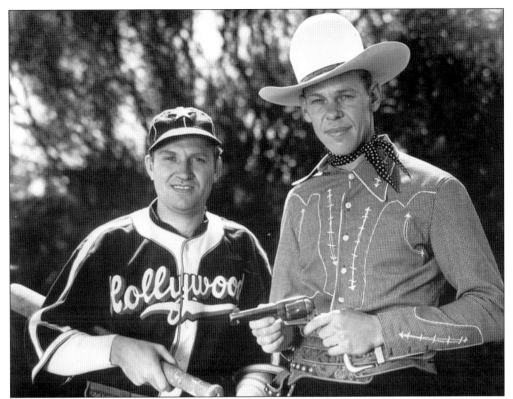

This photograph displays some baseball history from Gene Autry's past. The caption of the June 30, 1938, image reads, "Singing cowboy star (and future Angels owner) Gene Autry exchanges uniforms with Hollywood Stars outfielder Babe Herman. In the off-season, Herman was Gary Cooper's double during the *Pride of the Yankees* shoot. At the time, Cooper was a part-owner of the Stars."

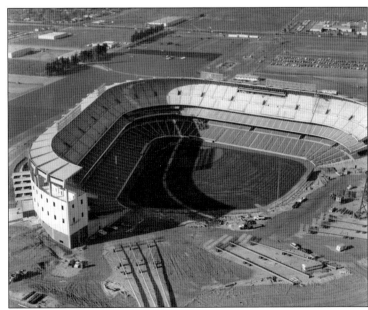

The ballpark nears completion in early 1966. The Angels would eventually play their first game at Anaheim Stadium on April 19, 1966, against the Chicago White Sox.

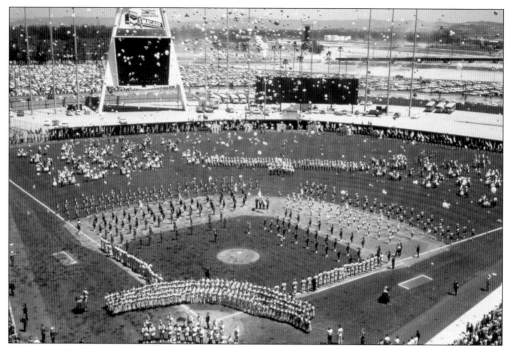

The Angels took on the Minnesota Twins on April 23, 1966, right after Angel Stadium opened. The "Big A" scoreboard is clearly visible beyond the left wall, as well as a lot of open space. In 1967, the stadium hosted the Major League Baseball All-Star Game, the first to be nationally televised. (Courtesy of Tom Duino and Richard Wojcik.)

Fans enter the stadium through the right-field parking lot on opening day in 1966. (Courtesy of Tom Duino and Richard Wojcik.)

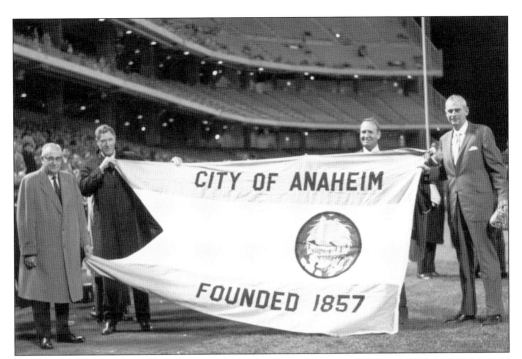

Anaheim's first city flag is being presented on April 11, 1967, by Mayor Fred Krein to California Angels owner Gene Autry in a pregame ceremony at Anaheim Stadium. From left to right are Mayor Krein, president and co-owner of the California Angels Rob Reynolds, California Angels co-owner Gene Autry, and California state senator John F. McCarthy.

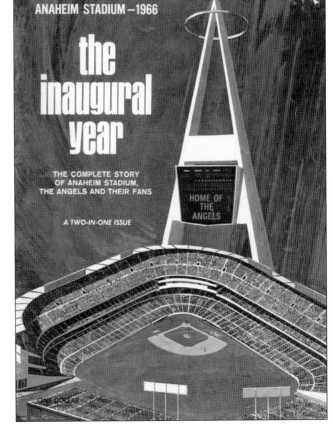

This 1966 yearbook was sold at the stadium during the inaugural year. Note the exaggerated iconic status given the to the Big A, which had become an Orange County landmark almost instantly.

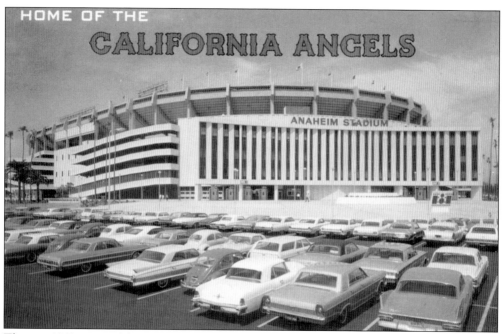

This is a 1968 postcard featuring Anaheim Stadium, the "Home of the California Angels."

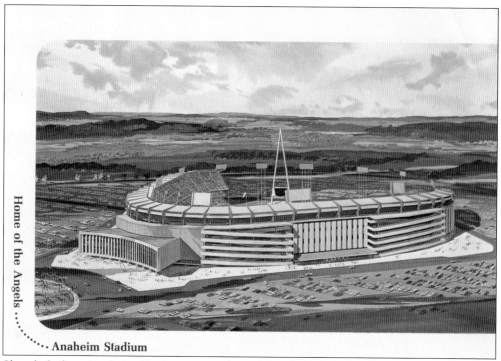

Shortly before Anaheim Stadium opened in 1966, the Anaheim Chamber of Commerce produced a brochure to illustrate how vital the park would become to the area. Though this is a stylized illustration of the park, it was in fact surrounded by open space the first few years of its existence.

Workers cover the field with tarp during a rare Southern California ran delay in 1966, the same year the stadium opened.

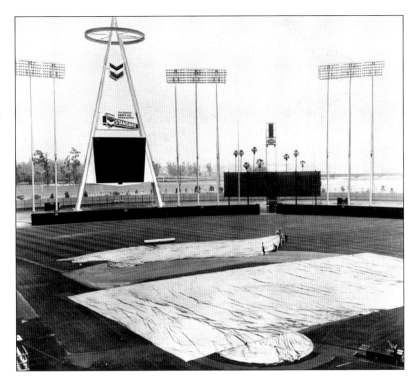

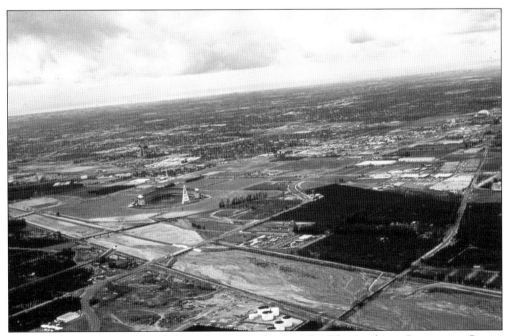

This aerial view looking toward the stadium was taken in 1970. The Anaheim Convention Center can be seen to the far right in the image.

This image was captured during Eagle Scout Night at Angels Stadium in 1973. The pitcher is Mike Holly, the catcher is Tom Searles, and the batter is Jeff Vaughn, all Orange County Eagle Scouts. This took place pregame before a thinly attended game between the Angels and the Baltimore Orioles.

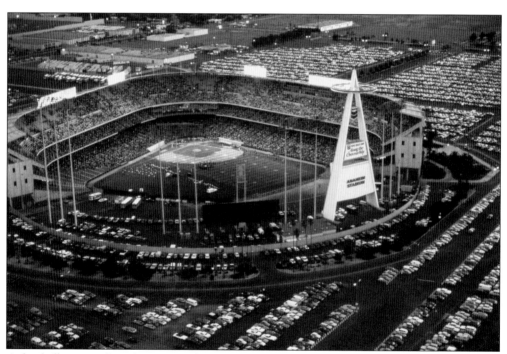

A football game takes place at Anaheim Stadium in 1974. Many notable individual baseball milestones and records were set and broken here by a host of Hall of Famers, among them Nolan Ryan striking out nine straight Boston Red Sox, Mickey Mantle's last game-winning home run, Reggie Jackson's 500th career home run, Rod Carew's 3,000th career base hit, Vladimir Guerrero's 400th career home run, and George Brett's 3,000th career base hit.

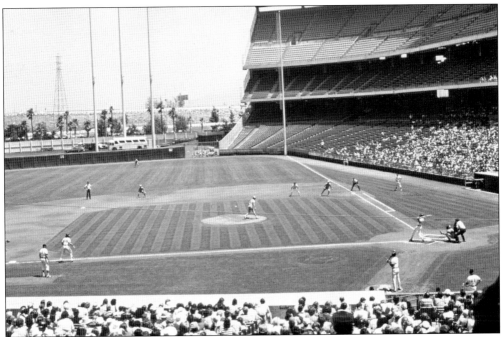

Pictured here is Angel Stadium on a quiet summer afternoon in 1977, two years before it became enclosed for football.

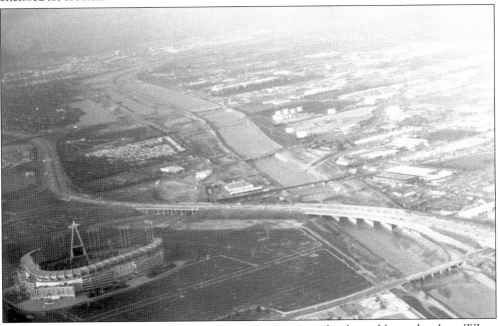

This is a 1978 aerial view of Angel Stadium. The Big A is clearly visible in the shot. When the stadium opened in 1966, the 230-foot-high letter "A," topped with a halo, was used as a scoreboard. The 210-ton sign loomed behind the left-field wall until 1980, when it was moved to the edge of the parking lot during the stadium's expansion. Originally, the $1 million price tag for the Big A was offset by the Standard Oil Company of California, which swapped the cost for advertising rights.

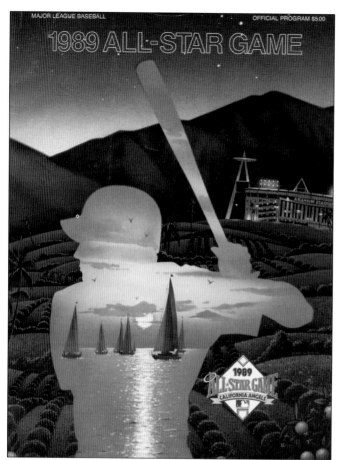

In 1989, the Major League Baseball All-Star Game returned to Anaheim after having last been played there in 1967 (it would be back again in 2010). Doc Severinsen played the National Anthem, Bo Jackson won the MVP Award, and the American League beat the National League by a final score of 12-9.

To accommodate the NFL's Los Angeles Rams, Anaheim Stadium underwent a renovation in 1979 and 1980 that completely enclosed it, which increased capacity for baseball to 64,593. The Rams made their debut on September 7, 1980, but left Anaheim for St. Louis following the 1994 season.

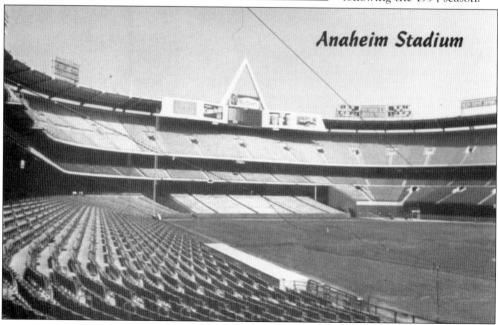

When Disney gained controlling interest in the team in 1996, the company made the decision to bring the stadium back to an open, baseball-only park. Anaheim Stadium renovations started on October 1, 1996. Due to the construction, seating capacity was reduced to 33,851 during the 1997 season. This view from the left-field corner shows the new scoreboard being built. Everything was ready for opening night in 1998.

This was the program for the opening of the remodeled stadium. By this point, the stadium had been renamed Edison International Field after the California-based public-utility holding company signed a $50 million, 20-year sponsorship deal. At the end of the 2003 season, the deal ended, and from that point on the stadium was called Angel Stadium of Anaheim.

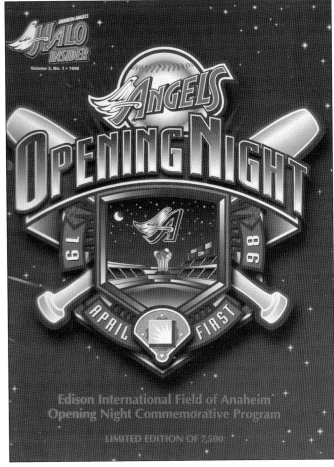

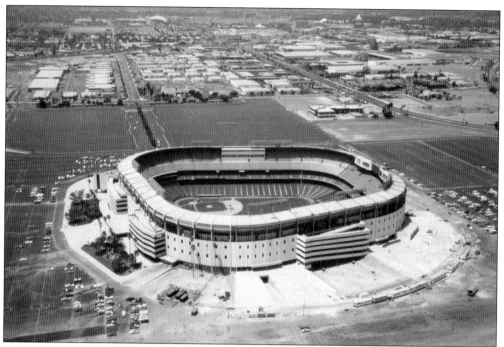

This 1980 image shows Angel Stadium after it had become enclosed for football just after the Los Angeles Rams moved in. Several major motion pictures were shot at the stadium over the years, including the final sequence of *The Naked Gun: From the Files of Police Squad!*, portions of the Disney remake of *Angels in the Outfield*, *The Fan*, and *Air Bud: Seventh Inning Fetch*, among others.

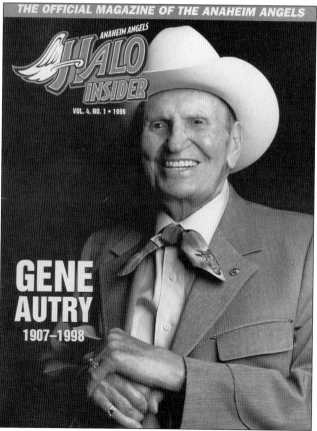

The Angels paid tribute to Autry after his death in 1998. The former singing cowboy was a beloved figure in Southern California and even in his later years would attend games, bringing a thrill to fans both young and old. His gentle, familial persona lent a charming air of decency and class to the organization, and his loss was mourned by fans and players alike.

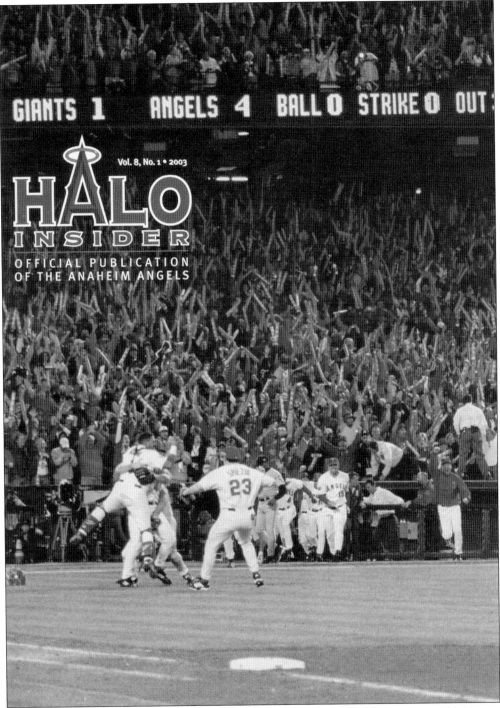

After more than 40 years as a major-league franchise, in 2002 the Angels won the World Series.

Pictured here is Angel Stadium of Anaheim as it appears today. After the 1998 renovations, the outfield was opened up to look more like how it was in 1966 (minus the Big A in left field, which remains on the outskirts of the parking lot adjacent to State Route 57).

Six

LOCAL LEGENDS

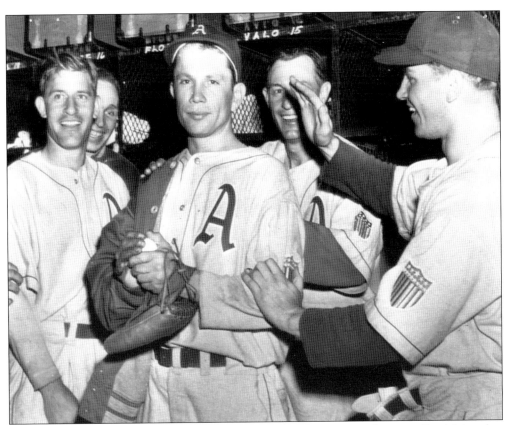

Jesus Flores Sandoval (with ball in hand) was born in 1914 on a rancho near Guadalajara but grew up in La Habra. Jesse Flores, as the world came to know him, pitched in the big leagues during the 1940s for the Chicago Cubs, the Philadelphia Athletics, and the Cleveland Indians. After that, he became a scout and helped guide future Hall of Famer (and fellow Orange County resident) Burt Blyleven into the majors.

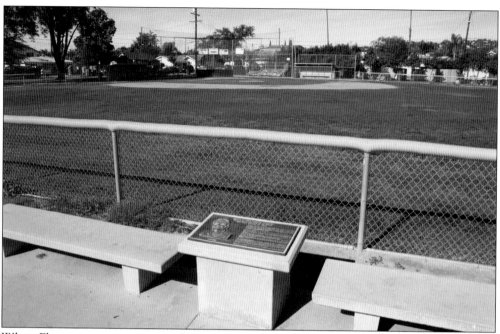

When Flores was growing up in Orange County, Mexicans were segregated from the white population, so local citrus growers sponsored all-Latino baseball teams. There were (among others) the Richfield Nine, Placentia Mexicans, and Flores's team, Los Juveniles. Flores was the best Latino ballplayer in Southern California's citrus leagues, which earned him his shot in the majors; he was the first Mexican American pitcher in the big leagues. He moved back to La Habra after retiring from baseball and coached at this field in Portola Park. Shamefully, La Habra's city fathers prevented him from moving into a white neighborhood unless he agreed to help the Mexican vote for Republicans; Flores refused.

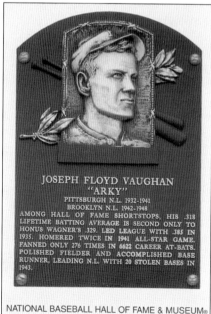

Arky Vaughan was born on March 9, 1912, in Clifty, Arkansas. When he was an infant, his family moved to Fullerton, California, where his father became an oil-field worker. Among Hall of Fame shortstops, Arky Vaughan's .318 lifetime batting average ranks second only to Honus Wagner's .327 mark. Vaughan played most of his career with the Pittsburgh Pirates but also spent some time with the Brooklyn Dodgers. Despite leaving his home state of Arkansas before his first birthday, one of Vaughan's schoolmates tagged the future ballplayer with the moniker "Arky." He graduated from Fullerton High School.

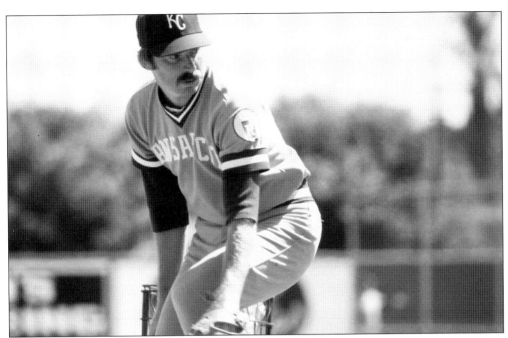

Dan Quisenberry, a graduate of Costa Mesa High School in 1970, was a submarine-throwing relief pitcher for the Kansas City Royals and a three-time All-Star. "Quiz" led the league in saves five times during his career and helped the Royals win two American League pennants and the 1985 World Series. In 1988, after eight years with the Royals, he was released; he then spent a year and a half with St. Louis before retiring after a brief stint with San Francisco. He was diagnosed with brain cancer in December 1997; on May 30, 1998, an emotional crowd was on hand to see him inducted into the Royals Hall of Fame. He died at the age of just 45.

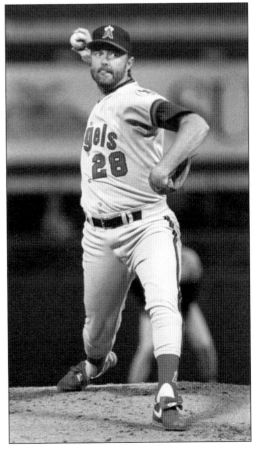

Hall of Fame pitcher Bert Blyleven won 287 games and ranks fifth on the all-time strikeout list. He was raised in Garden Grove and went through the local school system, attending Warren Elementary School and Walton Intermediate School before graduating from Santiago High School, where he was drafted in the third round of the 1969 amateur draft. Blyleven pitched in 22 seasons with the Minnesota Twins, Texas Rangers, Pittsburgh Pirates, Cleveland Indians, and California Angels.

Born in Bellflower, California, second baseman Jeff Kent graduated from Edison High School in Huntington Beach, California. Kent played at University of California, Berkeley prior to being drafted in the 20th round of the 1989 amateur draft by the Toronto Blue Jays. Kent won the National League MVP Award in 2000 with the San Francisco Giants. He is also the all-time leader in home runs among second basemen.

Shawn Green was drafted by the Toronto Blue Jays in the first round of the 1991 amateur draft. A graduate of Tustin High School, Green made his Major League Baseball debut on September 28, 1993. Despite having great numbers with the Los Angeles Dodgers, he was traded to the Arizona Diamondbacks in late 2004.

Lenny Dykstra played in the majors for the New York Mets (1985–1989) and Philadelphia Phillies (1989–1998). He was runner-up to Barry Bonds for National League MVP in 1993, when he led the league in hits, walks, and runs scored. On April 13, 2011, Dykstra was arrested for investigation of grand theft, a day after he was charged with a federal bankruptcy crime. Dykstra graduated from Garden Grove High School in 1981.

Three-time All-Star and four-time Gold Glove Award–winner Bret Boone graduated from El Dorado High School in Placentia. He was drafted by the Seattle Mariners in the fifth round of the 1990 amateur draft and went on to play for the Mariners, Reds, Braves, Padres, and Twins.

Former first baseman and outfielder Ryan Klesko, who played for the Atlanta Braves, San Diego Padres, and the San Francisco Giants, attended Westminster High School in Westminster, California. Klesko hit at least 21 home runs in 8 of his 13 major-league seasons, with a high of 34 homers in 1996. Klesko also became the first player to hit a home run in three consecutive World Series road games. He accomplished this against the Cleveland Indians in Games 3, 4, and 5 of the 1995 World Series.

Hall of Famer Gary Carter, a 1972 graduate of Sunny Hills High School in Fullerton, established himself as one of the premier catchers in the National League, both defensively and offensively. Carter broke in the majors with the Montreal Expos in 1974 and went on to play with the Mets in 1985 (they won the World Series in 1986). He joined the Giants in 1990 and the Dodgers in 1991 and then returned to Montreal, where he finished his career. In 2003, Gary Carter was elected to the Baseball Hall of Fame. Carter had previously been inducted into the New York Mets Hall of Fame in 2001. In 2008, he managed the Orange County Flyers of the Golden Baseball League, guided his team to the championship, and was named the league's manager of the year. Sadly, Carter died in February 2012 at the age of 57 from a brain tumor.

Randy Jones, who won the 1976 National League Cy Young Award, graduated from Brea-Olinda High School. Jones was drafted by the San Diego Padres in the 1972 Major League Baseball Amateur Draft and made his major-league debut on June 16, 1973. He pitched for San Diego through the 1980 season but was then traded to the New York Mets, and after the 1982 season he was sent to the Pittsburgh Pirates. The Pirates released him before the 1983 season started, thus ending his playing career. His career win-loss record was just 100-123, and he remains the only Cy Young winner with a losing record.

Mark Grace graduated from Tustin High School in 1980. With 2,445 career hits and a .303 lifetime batting average, Grace was a three-time All-Star and a four-time Gold Glove Award winner. His 511 career doubles rank 42nd in baseball history. Grace spent most of his career with the Cubs but finished with the Diamondbacks.

Angels favorite Brian Downing attended Magnolia High School in Anaheim. A catcher, left fielder, and designated hitter, Downing had 275 career home runs, 1,073 RBIs, and 2,099 hits. It is hard to believe he was actually cut from his high school team.

Pitcher Andy Messersmith (right) attended Western High School in Anaheim. He finished his career with a 130-99 record and a 2.85 ERA. He won 20 games in a season as both an Angel and a Dodger and was a four-time All-Star. He even won two Gold Gloves. He is pictured here with Yogi Berra.

Reliever Trevor Hoffman attended Savanna High School in Anaheim. Though he played infield in high school, he went on to become baseball's all-time leader in saves (601) over the course of an 18-year career. Hoffman, who spent most of his time with San Diego, was also a Cy Young runner-up twice and selected to seven All-Star Games.

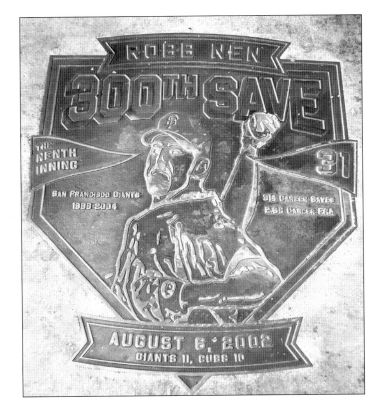

Reliever Robb Nen attended Los Alamitos High School. He was the son of another major leaguer, first baseman Dick Nen. Robb had 314 career saves for the Marlins and Giants and was a three-time All-Star.

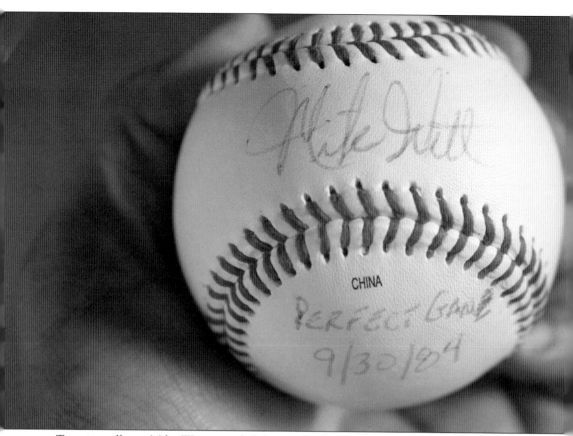

Two-time all star Mike Witt attended Servite High School in Anaheim. He won 117 major-league games (109 of them for the Angels), which included a perfect game at Texas on September 30, 1984.

Seven
MUSEUMS, MARKERS, AND MEMORIALS

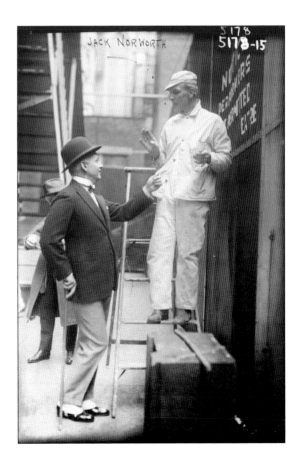

"Take Me Out To The Ball Game" was written by Jack Norworth (left) and Albert Von Tilzer in 1908 (not pictured). Norworth, a long-time Orange County resident, is buried at Melrose Abbey Cemetery. He was a very successful vaudeville entertainer/ songwriter and wrote the song "Shine On, Harvest Moon." Norworth spent a scant 15 minutes penning the lyrics to the classic "Take Me Out To The Ball Game," which is sung during the seventh-inning stretch at virtually every ballpark in the country.

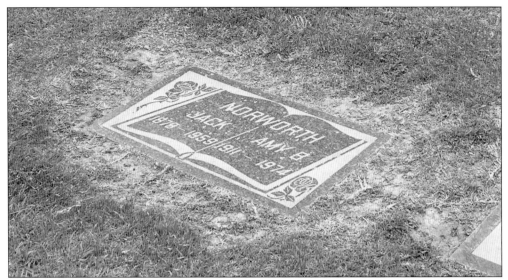

When the author wrote an article lamenting the fact that Norworth's grave, located right by Anaheim Stadium, seemed old and neglected, some fans got involved. Led by J.P. Myers of Diamond Bar, California, a movement was created to place a more appropriate marker for Norworth. Maria and Charles Sotelo from Hesperia, California, offered to design and donate a marker. Jamie Chisick donated money for the marker, for which the author wrote the text. A deal was struck with the cemetery to have the marker placed near Norworth's grave.

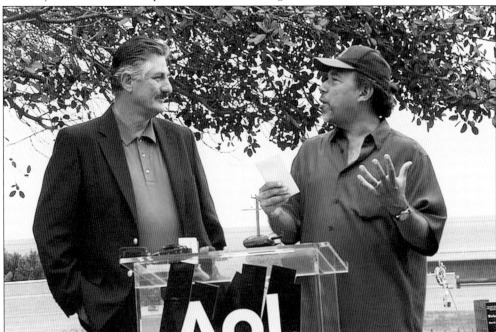

On July 12, 2010, with the help of AOL, a ceremony was held to unveil the Jack Norworth marker. Hall of Fame pitcher Rollie Fingers (left) joined the author to make the presentation. Interestingly, Norworth, who lived in Laguna Beach from 1940 until his death in 1959, ran a Laguna store called It's a Small World, a novelty shop dealing with collectible miniatures located 1820-26 South Coast Highway in Laguna Beach.

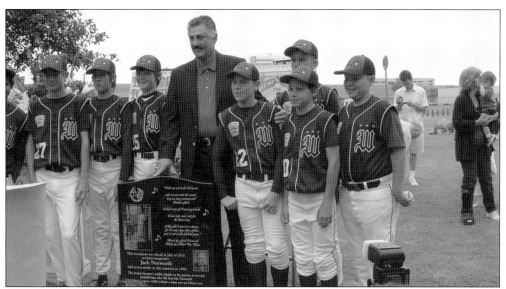

Also on hand were players from the Laguna Beach Little League, which Norworth helped start in the early 1950s. Each year in Laguna, the first-place team is awarded the Jack Norworth Trophy, a prize given to Norworth in 1958 at a Dodgers game in Los Angeles (ironically, on July 12, the same date of the cemetery ceremony). Each opening day of the Little League season in Laguna, Crackerjacks are given to each player in honor of Norworth's song.

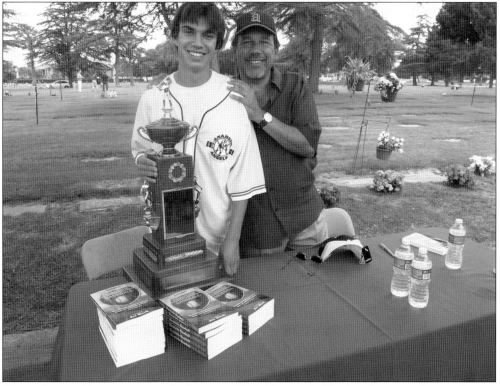

The author and his son pose with the actual Jack Norworth Trophy, the one still passed on to the winning team in Laguna each season, at the ceremony.

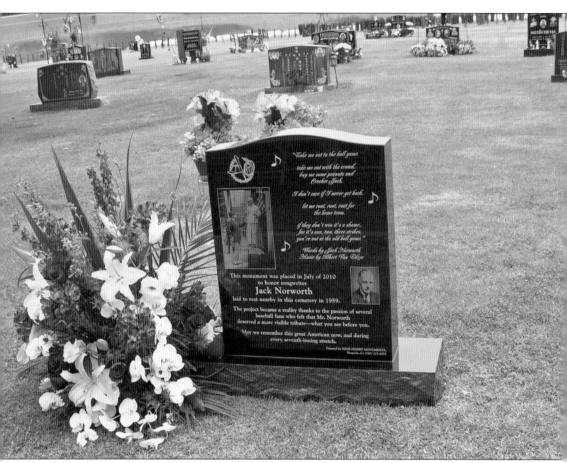

Every person involved was very proud to help create a landmark celebrating such an interesting part of Orange County, as well as baseball history.

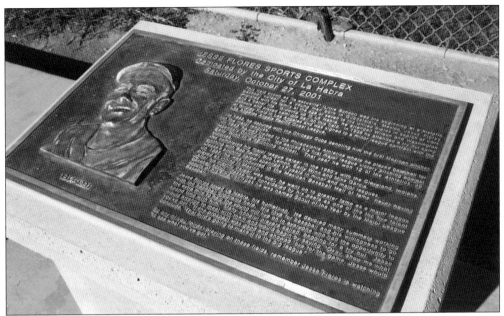

At Portola Park in La Habra, the fields have been dedicated to famed Mexican baseball legend Jesse Flores, who played semipro baseball on these very diamonds before debuting with the Chicago Cubs in 1942. After his playing and scouting days were over, he devoted many summers working with the baseball programs there. In 2001, the fields were named in his honor, and this marker was placed on the grounds.

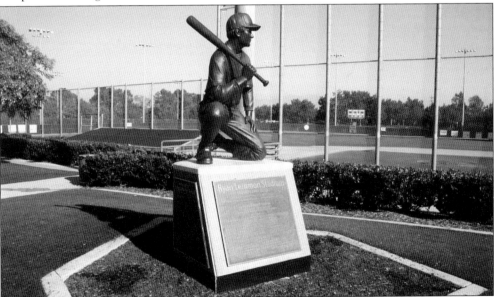

Ryan Lemmon Stadium is the main baseball field at Windrow Athletic Community Park in Irvine. Ryan Lemmon was an Irvine resident and star baseball player from Woodbridge High School. He died in a car accident following his first year of college at Pepperdine University, and in 1995 his father established the Ryan Lemmon Foundation as a way to give back to the baseball community. A life-size bronze statue is prominent at the park, recognizing him and symbolizing the virtues of youth athletics.

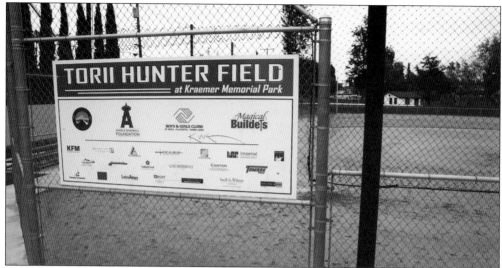

In 2008, Angels star outfielder Torii Hunter helped construct a youth softball field largely through monetary donations made by him and the Angels Baseball Foundation, as well as in-kind services of dozens of local companies and volunteers. Torii Hunter Field is in the city of Placentia in Kraemer Memorial Park, located on the southwest corner of Walnut and Chapman Avenues.

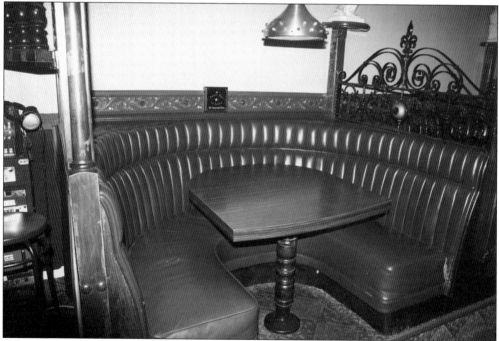

The Continental Room, originally opened in 1925, is billed as the "Oldest drinking establishment in Fullerton." Inside, one can actually sit in legendary Dodger manager Tommy Lasorda's booth. Though he has lived in Fullerton since 1964, this is not where Lasorda got comfortable after games at Dodger Stadium. This booth once sat in Little Joe's, a once popular Italian restaurant near Dodger Stadium that Lasorda frequented many a night after home games. It closed in 1998, but the booth was brought down to Fullerton after that, and today it lives on in Tommy's adopted hometown.

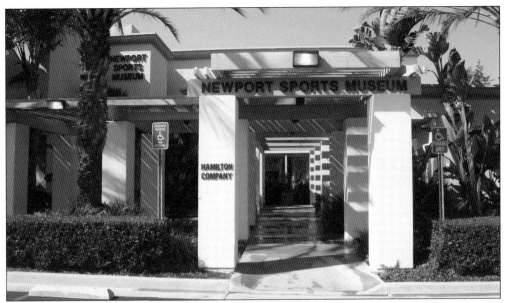

The Newport Sports Museum may have been inspired in 1953 when, at the age of 12 years old, John W. Hamilton was given a signed football from the Look All-American football team. As the years passed, Hamilton's passion for collecting sports memorabilia grew, as did his collection. His impressive collection is now one of the largest displays of sports memorabilia ever assembled. In 1995, Hamilton, along with several athletes, decided to open the Newport Sports Museum. Always free to the public, it is one of the premier sports museums in the world and a world-class baseball memorabilia reliquary.

Just before entering the museum, visitors pass through a vintage turnstile rescued from Connie Mack Stadium in Philadelphia. Given that Mack brought his Philadelphia Athletics team to spring train in Anaheim, it seems somewhat appropriate.

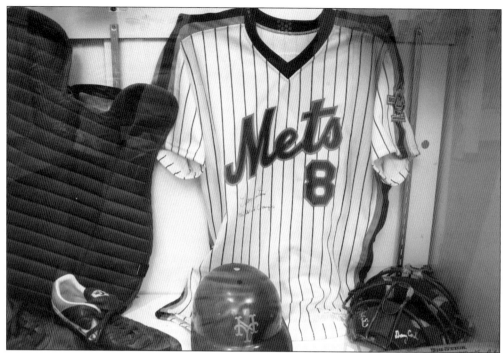

The museum features an impressive display dedicated to Orange County's own Hall of Fame catcher Gary Carter, who attended Sunny Hills High School in Fullerton.

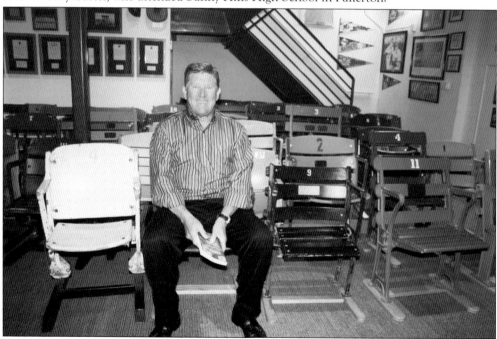

Museum founder John Hamilton is seen here sitting on an item of the most prized collections in the museum: a dazzling array of classic ballpark seats, which includes some extremely rare pieces from Cleveland's League Park and Cincinnati's Crosley Field, as well as original Yankee Stadium seats.

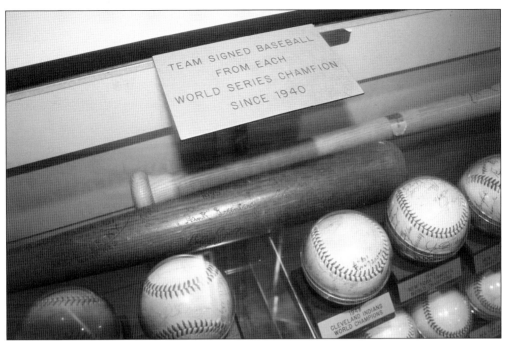

Among the many valuable artifacts at the museum are team-signed baseballs from every World Series champion since 1940.

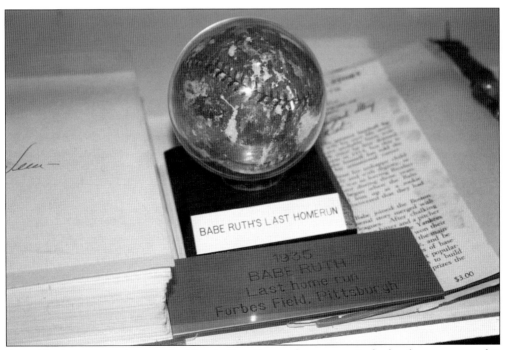

Arguably the rarest and most prized baseball artifact at the museum is the last home run ever hit by Babe Ruth, no. 714, which dates back to Ruth's final playing days as a Boston Brave in 1935.

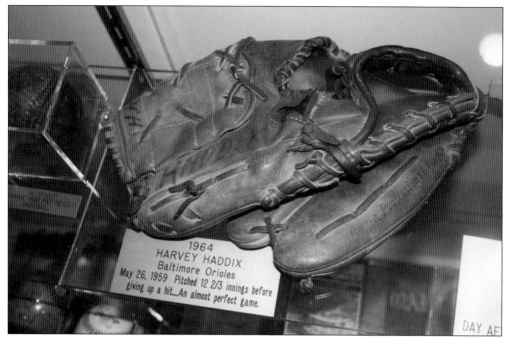

Another extremely interesting item is the glove worn by pitcher Harvey Haddix the night he pitched an almost-perfect game on May 26, 1959. Haddix pitched 12 2/3 innings before giving up a hit.

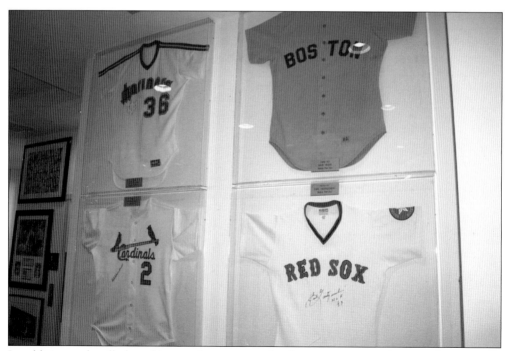

In addition to locally based items, the museum also features many uniforms and equipment connected to greats of the game from all over the country.

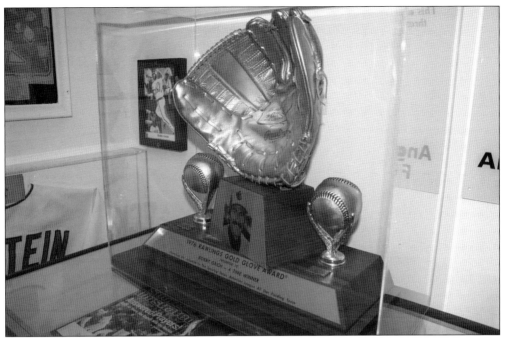

Naturally, many items relate to the then California Angels, now known as the Los Angeles Angels of Anaheim. This was the Rawlings Gold Glove Award presented to star Angels infielder Bobby Grich.

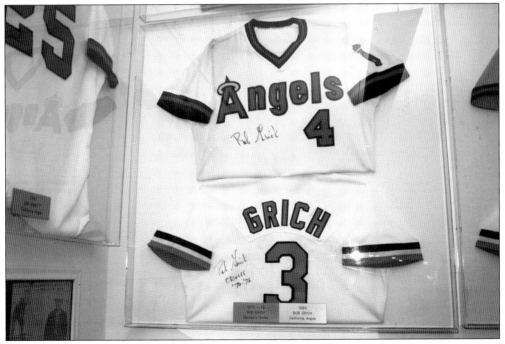

There are several other Bobby Grich artifacts in the museum, most notably the signed, game-worn jerseys from 1970 while he was a Baltimore Oriole and a 1980 Angels jersey.

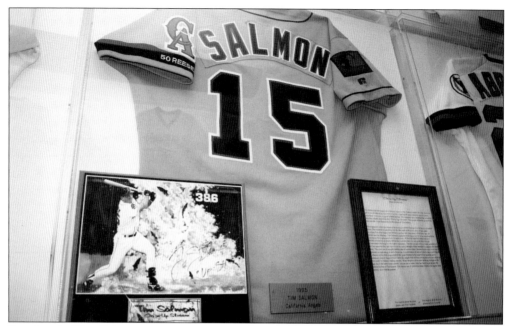

Fan favorite Tim Salmon remains an icon in Orange County. He played his entire career with the Angels, and throughout his impressive run with the team he came to symbolize not just heart and ferocious competitive spirit, but also gentlemanly class and character. This game-worn Salmon jersey is from 1995.

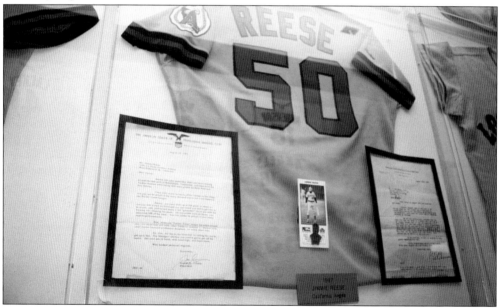

In 1972, at age 71, former player and coach (as well as Babe Ruth's roommate) Jimmie Reese asked the Angels for a job and was hired as conditioning coach. Reese's main specialty, however, was hitting fungos in practice, using a bat he made himself. A master woodworker, a frame he constructed is also in the museum. Interestingly, Reese, who died in 1994 at age 92, is believed to be the oldest person ever to regularly wear a uniform in an official capacity in the history of organized professional baseball in North America.

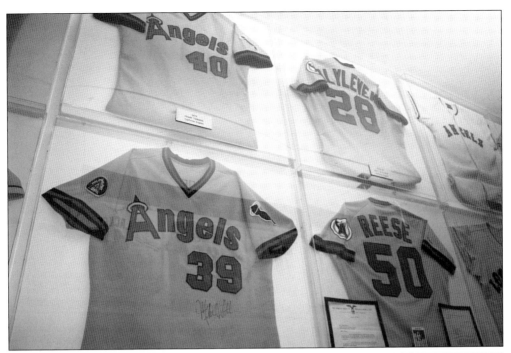

Pictured here are game-worn jerseys from Frank Tanana, Burt Blyleven, Mike Witt, and Jimmie Reese.

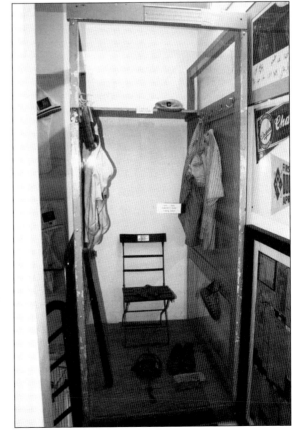

This display at the Newport Sports Museum is truly stunning: a complete and original 1910 locker-dressing cubicle from Comiskey Park in Chicago.

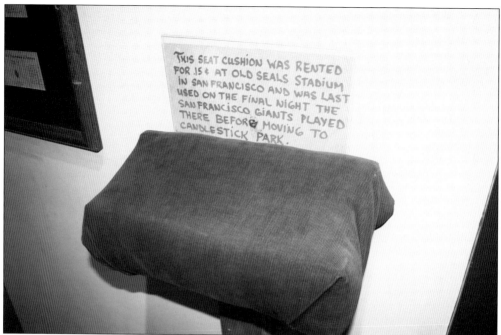

Among the stranger baseball artifacts at the Newport Sports Museum is this seat cushion from Seals Stadium in San Francisco. It could be rented at the ballpark for 15¢.

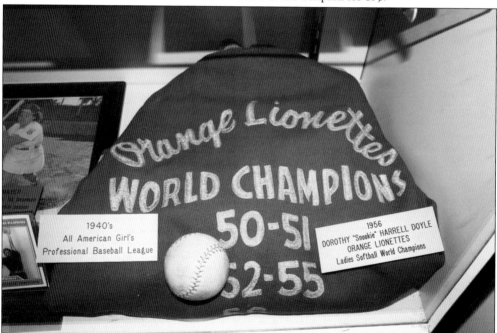

This is the jacket of Dorothy "Snookie" Harrell Doyle, renowned All-Star shortstop for the Rockford Peaches, one of the top players in the All-American Girls Professional Baseball League and an inspiration for the 1992 film *A League of Their Own*. She also played for the Orange Lionettes fast-pitch softball team of California from 1956 to 1960, participating in several major national tournaments.

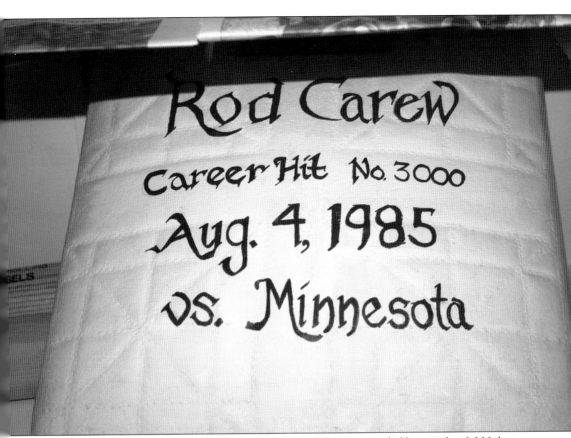

On August 4, 1985, California Angels Hall of Famer Rod Carew recorded hit number 3,000 during a game in Anaheim against his former team, the Minnesota Twins. Today, the first base Carew touched after his single to left off of Frank Viola can be found at the Newport Sports Museum.

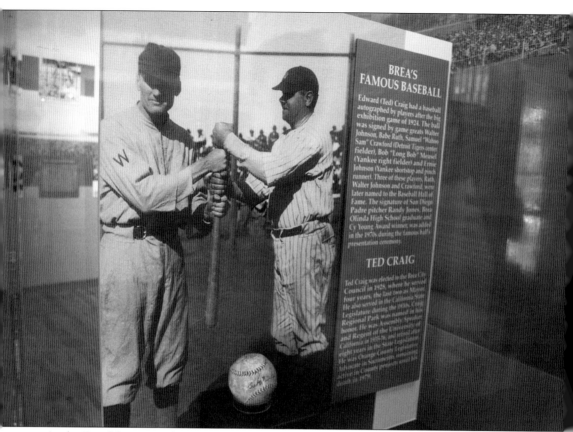

At the Brea Museum and Heritage Center, this is part of the permanent exhibit dedicated to the memorable Walter Johnson/Babe Ruth game at the Brea Bowl.

This poster at the Brea Museum and Heritage Center advertises the memorable game between Walter Johnson and Babe Ruth.

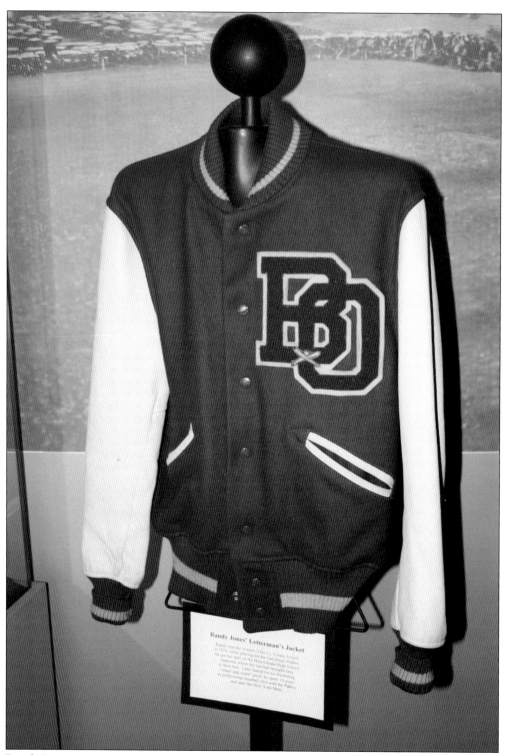

Randy Jones's Brea Olinda High School letterman jacket is also on display at the Brea Museum and Heritage Center.

Fullerton High School has produced dozens of notable alumni, all of whom can be seen on the school's Wall of Fame, located in its administration building. In addition to baseball Hall of Famers Walter Johnson and Arky Vaughan, Steve Busby (who tossed two no-hitters in his career) also hangs on the wall near a photograph of this gentleman, Alfonso Marquez. The first Mexican-born umpire in major-league history, Marquez has officiated two World Series, two Championship Series, and five Division Series, as well as the 2006 All-Star Game. He is also in the Mexican Baseball Hall of Fame.

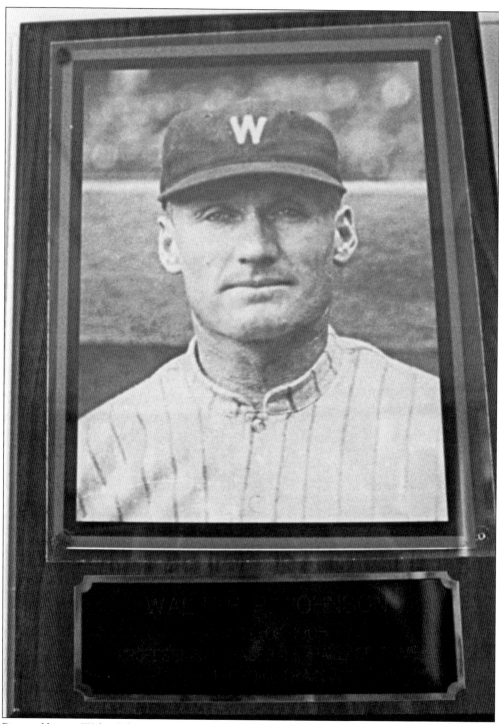

Pictured here is Walter Johnson's plaque on the Fullerton High School Wall of Fame. Interestingly, Fullerton Union High is the only high school to produce three ballplayers who pitched no-hitters in the major leagues: Johnson, Steve Busby of the Kansas City Royals, and Mike Warren of the Oakland A's.

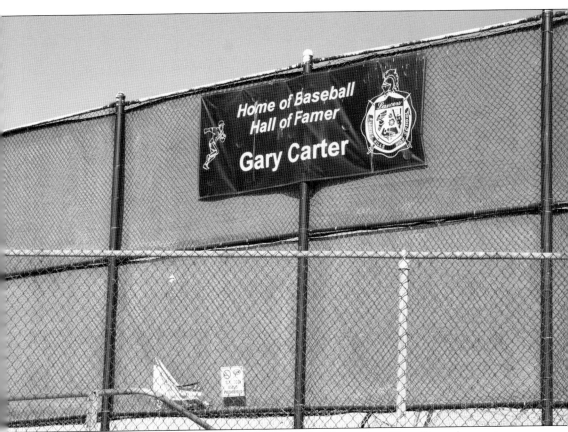

Sunny Hills High School in Fullerton honored its Hall of Fame alum Gary Carter by naming a field after him. Current school athletic director Ralph Trigsted was working at Sunny Hills High School when Carter (class of 1972) enrolled in 1969, and the two remained lifelong good friends. Sadly, Carter died from brain cancer on February 12, 2012, at the age of 57.

Fullerton honored Walter Johnson by naming a street after him. Johnson Place is located in the city just off Carhart Avenue near West Malvern Avenue.

Harry Gaspar was a phenom in 1909, going 19-11 for the Cincinnati Reds. The next season, he led the league in saves (not a statistic at the time) with seven, although he only appeared in 17 games in relief. A right-handed pitcher over the course of four seasons (1909–1912) with the Cincinnati Reds, Gaspar he compiled a 46-48 record in 143 appearances, with a 2.69 ERA and 228 strikeouts. Originally from Kingsley, Iowa, Gaspar eventually settled in Orange, California, where he died in 1940 at the age of 57. He is buried in Orange County at the Holy Sepulcher Cemetery in Orange.

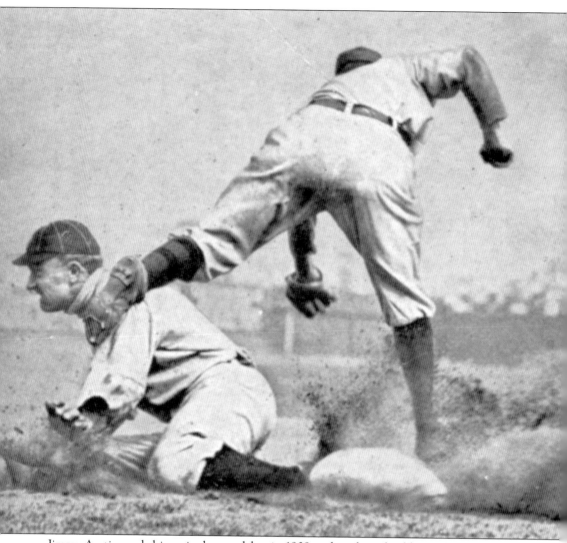

Jimmy Austin made his major-league debut in 1909 at the relatively old age of 28. He played two seasons in New York but was traded to the St. Louis Browns in 1911, thus beginning a 30-year career with the Browns as a player and coach. Austin lives forever in a famed photograph being spiked by Ty Cobb. After 32 years in the majors, Austin retired to Laguna Beach, California, where he had made his home since 1913. A popular figure, Austin served as mayor of the town during the 1940s. He died from congestive heart failure on March 6, 1965, at the age of 85 and was buried in Melrose Abbey Memorial Park in Anaheim.

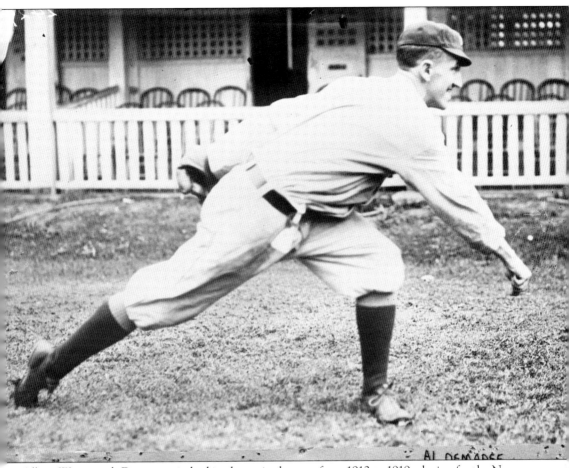
Albert Wentworth Demaree pitched in the major leagues from 1912 to 1919, playing for the New York Giants, Philadelphia Phillies, Chicago Cubs, and Boston Braves. He died in 1962 and is buried in Orange County at Harbor Lawn-Mt. Olive Memorial Park in Costa Mesa.

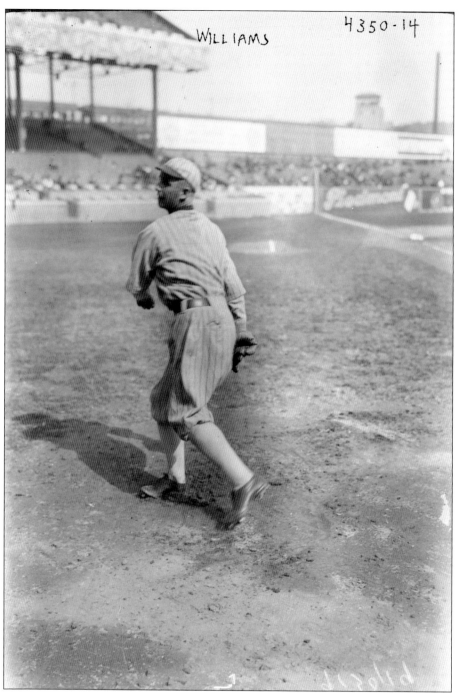

As a pitcher, Claude "Lefty" Williams relied on his curveball and the excellent defensive outfield of the Chicago White Sox for his success in the majors, but he is primarily remembered because he was banned from baseball for his participation in fixing the 1919 World Series. Out of organized baseball, Williams barnstormed and played in outlaw leagues for a few years before moving to California, where he went into the landscaping business. He died in Laguna Beach, California, in 1959 and is buried at Melrose Abbey Memorial Park in Anaheim.

Jesse Lawrence Barnes played 13 seasons for the Boston Braves, New York Giants, and Brooklyn Dodgers from 1915 to 1927. In 1919, he led the league with 25 wins, and on the last day of the regular season, Barnes pitched against the Philadelphia Phillies. The game lasted just 51 minutes, still officially the shortest nine-inning game ever played. On May 7, 1922, he threw a no-hitter against the Philadelphia Phillies. Barnes died in New Mexico while on a family vacation and is buried today in Orange County at Westminster Memorial Park in Westminster.

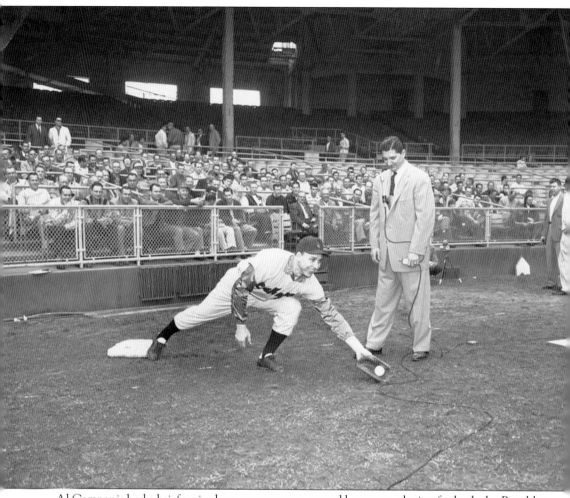

Al Campanis had a brief major-league career as a second baseman, playing for both the Brooklyn Dodgers and the Montreal Royals, the Dodgers' minor-league team. He is most famous, though, for his position as general manager of the Los Angeles Dodgers from 1968 to 1987. He was fired from his post because of a high-profile incident in which he made remarks seen as racist during a live interview on April 6, 1987. He died in 1998 and is buried in Orange County at Westminster Memorial Park in Westminster. In this image from a baseball clinic held at Wrigley Field in Los Angeles on February 8, 1958, Campanis is seen to the immediate right of Dodger Gil Hodges as Hodges demonstrates a fielding play.

In 2011, Huntington Beach's Ocean View Little League team did what no other Orange County Little League team had ever done: under the leadership of manager Jeff Pratto, they won the Little League World Series. Here, longtime Dodgers manager Tommy Lasorda greets them at Dodger Stadium. (Courtesy of Wendy Kotkosky.)

Ocean View Little League team manager Jeff Pratto is seen here being interviewed by reporter Michael Eaves during the team celebration at Dodger Stadium in honor of their Little League World Series Championship. (Courtesy of Wendy Kotkosky.)

The team was honored in many places and in many ways. This image shows a victory parade at Disneyland. (Courtesy of Wendy Kotkosky.)

The field at Murdy Park in Huntington Beach, where Ocean View Little League team plays, became a landmark of sorts after they won the 2011 Little League World Series. Now, this field is indelibly connected to Anaheim Stadium, La Palma Park, Amerige Park, and the Olinda oil field diamond where Walter Johnson started playing about 110 years earlier. It is now a true part of Orange County baseball history—yet another field of dreams.

Discover Thousands of Local History Books Featuring Millions of Vintage Images

Arcadia Publishing, the leading local history publisher in the United States, is committed to making history accessible and meaningful through publishing books that celebrate and preserve the heritage of America's people and places.

Find more books like this at
www.arcadiapublishing.com

Search for your hometown history, your old stomping grounds, and even your favorite sports team.

Consistent with our mission to preserve history on a local level, this book was printed in South Carolina on American-made paper and manufactured entirely in the United States. Products carrying the accredited Forest Stewardship Council (FSC) label are printed on 100 percent FSC-certified paper.